# HIDDEN
# HISTORY
*of*
# RHODE
# ISLAND

# HIDDEN HISTORY

# *of*

# RHODE ISLAND

NOT-TO-BE-FORGOTTEN TALES
*of the* OCEAN STATE

GLENN LAXTON

Charleston    London

THE
History
PRESS

Published by The History Press
Charleston, SC 29403
www.historypress.net

First published 2009

Manufactured in the United States

ISBN 978.1.59629.728.9

Library of Congress Cataloging-in-Publication Data

Laxton, Glenn
Hidden history of Rhode Island : not-to-be-forgotten tales of the Ocean State / Glenn
Laxton.
p. cm.
ISBN 978-1-59629-728-9
1. Rhode Island--History--Anecdotes. 2. Rhode Island--Biography. I. Title.
F79.6.L39 2009
974.5--dc22
2009043989

*To My Loving Family*

# CONTENTS

# CONTENTS

# FOREWORD

G lenn Laxton asked me to write the foreword to this book. I had never written a foreword before and did not know exactly what I was doing, but I found his book fascinating. It records history with heart and blood and a warmth particular to Rhode Island history.

For instance, General Richard Prescott, the commander of the British forces that invaded and captured Newport, was himself captured in May 1777 in the home of a well-to-do merchant on what is today the Middletown-Portsmouth line. The general was romancing the owner's wife on the top floor while the owner was living on the first floor. His capture by Lieutenant Colonel William Barton, a Warren, Rhode Island hatter, was hailed by all, including George Washington.

Laxton's book rather thoroughly proves the extraordinary fact that a number of Rhode Islanders were on the *Titanic* when it struck an iceberg and sank on April 15, 1912, and chronicles the lives of the local women who survived.

A chapter in the book called "The Fireman's Statue" is dedicated to Samuel S. Collyer, and Fireman's Park in Pawtucket is dedicated to all firefighters in that city. Collyer was killed in a tragic accident while responding to a fire. He is considered the city's first fire chief.

Glenn Laxton's book also records Rhode Island's close connection with the official adoption of "The Star-Spangled Banner" as the national anthem by one of the state's three congressmen.

There are twenty-three chapters in this book, and as a collection of Rhode Island historical anecdotes, this "Not-to-Be-Forgotten" book probably holds the record for the number of incidents of coverage on Rhode Island history. I have never read anything else that even comes close.

Bruce Sundlun
Governor of Rhode Island
1991–1995

Bruce G. Sundlun has had a long and distinguished life as an attorney, businessman and World War II pilot. He survived being shot down in his B-17 Flying Fortress in 1943 and managed to escape to Switzerland. He was awarded the Purple Heart, Chevalier of the Legion d'Honneur, Distinguished Flying Cross and Air Medal with oak leaf cluster.

He currently teaches political science and Rhode Island history at the University of Rhode Island and remains active in the Democratic Party.

# ACKNOWLEDGEMENTS

S pecial thanks to Adam and Diane Laxton for helping me put all this material on disk instead of having it end up in outer space; all of the families who survive the subjects of these stories for gladly answering questions and providing photographs and illustrations; the Newport Art Museum; Mark Petteruti for being so passionate about the legacy of his grandmother, Bertha Mulvihill, one of the *Titanic* survivors; the Mariners Museum in Newport News, Virginia; Kathleen and Joe Connolly Jr.; Peter Nelson; Amherst College Archives; Arthur E. Rash; Gordon Rowley; the *Pawtucket Times*, January 19, 1893; the Pawtucket Fire Department; the *New York Times*, April 19, 1873; the *Masonic Magazine*, July 1873; the Old North Burial Ground, Providence, Rhode Island; Swan Point Cemetery, Providence, Rhode Island; Terry Ariano of the Elephant Hotel in Somers, New York; the Rhode Island Historical Society; the Deborah Cook Sayles Pawtucket Public Library; Historian Tom Shannahan; the Moshassuck Cemetery in Central Falls; Beverly Viau; Joan Gregory Viau; Doris Benn; and the staff of The History Press, especially Saunders Robinson and Emily Navarro, who guided me through the process of modern-day writing and publishing. I am sure I've left some people out, and for that I apologize but remain grateful.

# INTRODUCTION

When I was in grammar school, I learned about Roger Williams. I was more interested in Ted Williams, however, and the history of anything never quite sunk in. Same for the Pilgrims. It was Plymouth Rock and not rock-and-roll. The point is that we weren't taught much more than ol' Roger and those Pilgrims as far as Rhode Island history is concerned, and it isn't a whole lot better today. There is history on every corner of Rhode Island, from its homes to its streets and the people who lived and worked there, and most are no more than a memory to their families.

History, even if it is hidden, is a study of things past. Sadly, much of history lies buried in our cemeteries and is gone forever. I have found it fascinating to discover something of the past, such as an obituary of an interesting person, and to trace it to the present and find out who the survivors were up to the present day. Most people want to tell their stories, and they are usually more than interesting.

Look at the list of Rhode Island women who survived the sinking of the *Titanic*. How about the little boy who escaped that awful night in 1912 to live on as an artist and storyteller well into old age? Walking through cemeteries, I have been struck by how many stones bear the message that the person whose name is on that stone actually died at sea. There are hundreds of such names, but of course travel by ship was the way to go in the eighteenth and nineteenth centuries. Each story was fascinating to

research and write. I got to know the women and little boy who survived the *Titanic* sinking on that awful night of April 15, 1912, and read their own words, which they told repeatedly during their long lives.

I had heard the story of Robert the Hermit from my mother, Mildred, herself an accomplished writer and learned historian. One reason I have included it here was that no one else seemed to have heard the story, and I thank the Seekonk, Massachusetts library for letting me dig through old town records to find out about his death and burial in what today is called the Rumford section of East Providence, Rhode Island. Robert was interviewed by a local reporter in the early nineteenth century after curiosity got the best of people who watched him wandering around the city for decades and wanted to know more. All they had to do was ask him.

When I was a reporter for WPRI-TV in Providence, I created a series called "Not to Be Forgotten," which dealt with people like Robert who should be known and remembered but are not. One story that photographer Scott Delsole and I re-created was Hurricane Carol in 1954, which tore through southern New England, leaving a trail of death and destruction in its path. During the storm, an incredibly brave Rhode Island State Trooper named Danny O'Brien rescued scores of potential victims from the raging, rising waters of the Atlantic Ocean off Matanuska Beach in South County. Sadly, after leading the last resident to safety, he was swept away. His sister, nephew and fiancée were of great help in remembering him and providing photos of the happy young trooper.

Edward Bannister was a renowned artist creating masterpieces in Rhode Island despite his struggles for recognition as an African American painter. His wife Christiana is featured here because she is truly forgotten, even though she was one of the best and most accomplished hairdressers of her time. She also established a home for aged colored women, today known as Bannister House in Providence and open to people of all races.

No less than George Washington was among the first to congratulate Major William Barton for his morale-boosting capture of the hated British general Richard Prescott at a farm in Portsmouth, Rhode Island, at the height of the Revolutionary War. Major Barton, who went on to become a general, ended up in a Vermont prison for many years, only to be bailed out against his wishes by his old friend and admirer, Marquis de Lafayette.

I loved finding out about the North Smithfield farm boy who ended up in the Baseball Hall of Fame at Cooperstown, New York, and of the little minesweeper caught between the big guns of Allied battleships and the well-entrenched German heavy boomers firing at one another over its head at Normandy on June 6, 1944.

Perhaps the best compliment any historian can receive is to have someone read what he has written and say, "I didn't know that!" I hope you will have the same reaction.

# A Cast *of* Unusual *and* Overlooked Characters

# THE MYSTERIOUS LIFE OF
# ROBERT THE HERMIT

His body was found by neighbors, lying as if asleep inside the hut he had built into a hill at the foot of the Washington Bridge on land owned by Tristam Burges in the Fox Point section of what was at the time Seekonk, Massachusetts, which is now East Providence. (Today, Seekonk, Massachusetts, sits on the Rhode Island border. Both states claimed Seekonk was theirs until the court settled the issue and incorporated it into Massachusetts in 1812.) For fourteen years, he had lived in this thick pine grove on Arnold's Hill as a hermit, well known to residents of Rhode Island by one name: Robert. He was described as a friendly person with an agreeable disposition, but no one knew his history, where he had come from or why he chose to live such a solitary life with no income and only nature and occasionally good folks he had gotten to know providing food and shelter.

The *Literary Cadet* carried this poem in June 1826:

> *Beneath a mountain's brow, the most remote*
> *And inaccessible by Shepards trod.*
> *In a deep cave, dug by no mortals hands*
> *An hermit lived…a melancholy man*
> *Who was the wonder of our wand'ring swains:*
> *Austere and lonely…cruel to himself*
> *They did report him…the cold earth his bed,*
> *Water his drink, his food the Shepard's alms.*
> *I went to see him, and my heart was touched*

*With reverence and pity, Mild he spake,*
*And entering on discourse, such stories told,*
*As made me off re-visit his sad cell.*

Robert died on April 1, 1832, at about seventy years of age. That afternoon, following a funeral service at his hut, he was buried in a pauper's grave at Carpenter's Cemetery next to what today is the Newman Congregational Church in Rumford, Rhode Island.

The man on whose land Robert lived was a retired congressman named Tristam Burges, who resided in a magnificent home called Watchemoket Farm. He served as chief justice of the Rhode Island Supreme Court and ran unsuccessfully for governor on the Whig ticket. He allowed Robert a small space for his hut in return for some landscaping work. Robert seemed to enjoy cultivating the land at Watchemoket Farm but never let his vegetables mature, instead picking them and feeding them to the farm's cattle. Inside the hut was a stool, an oak bench (which served as Robert's bed) and pieces of eating utensils all in an area barely able to accommodate the old man's portly frame.

People were strangely respectful of this mysterious light-skinned African American, and he returned that respect. Most who knew of Robert or saw him when he ventured into Providence wanted to know his story. Eventually, he relented, and in January 1829, a Providence printer, Henry Trumbull, urged on by his colleagues, approached Robert with the idea of publishing a story about him in his own words. Late one morning, Trumbull made his way to the hut, where this strange and engaging man greeted him with great warmth. The printer quickly explained that he was not on a mission to merely satisfy the public curiosity but had Robert's well-being in mind. He hoped to write Robert's story to provide him with some income. Trusting the stranger, Robert finally agreed to lay out the narrative of what had been an extraordinary and tragic life.

From that tiny hut, Robert revealed stories that stunned Trumbull. Robert the Hermit was, in fact, Robert Voorhis. Born in Princeton, New Jersey, about 1770, Robert has little remembrance of his parents. His father was a white Englishman whom he never knew; his mother had been shipped here from Africa as a slave. The surname Voorhis was given to him by his slave master when he was a boy. His master's oldest daughter married John Voorhis, and Robert was shipped to Georgetown, outside Washington, D.C., at age four to serve his new master; it was the last time he saw his mother. He studied under a shoemaker to learn the trade but soon found, to his dismay,

Robert the Hermit lived in a self-styled cave near what today is the Washington Bridge in East Providence. *Illustration by Gordon Rowley.*

that he had no talent for such a profession. He returned to the Georgetown plantation, where he continued to live and work as a gardener until he was nineteen. It was there that he met and fell in love with Alley Pennington, also a slave. Alley promised to marry him if he could attain his freedom and take her away. His master agreed that if he could come up with fifty pounds, he would sell him his freedom and the lovers would be free to marry. However, the fates were not so kind.

A man named James Bevins, whom Robert thought to be a friend, paid Robert's master the fifty pounds, and Robert set out to earn the sum to pay him back. Alley and Robert were married and had two children. After three years, he thought that his debt was paid and he was about to become a free man. Suddenly, his life changed dramatically and tragically, throwing him on a path that would make him the hermit people would grow to know.

One day, without warning, Bevins and another man burst into his small home and seized Robert, saying that he still owed the money that Bevins was supposed to have received over the past three and a half years. Robert protested, but relentless, they dragged him outside, calling him a liar. For the rest of his life, Robert would recall the screams of his family, "whose shrieks would have pierced the heart of anyone but a wretch like himself [Bevins]."

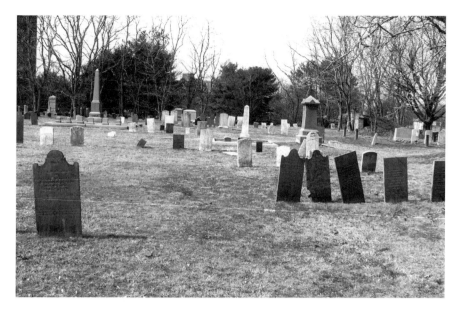

Seekonk town records indicate that Robert was buried in this cemetery next to the Newman Congregational Church in Rumford, Rhode Island. *Author's collection.*

Robert was taken to a schooner and forced to board it. He recalled, "For fear of escape I found irons were to be substituted for the ropes with which they had bound me."

Three days later, the schooner arrived at Charleston, South Carolina, where, "without being relieved of my irons, I was conveyed to and lodged in prison, where I suffered to remain in solitude five days. From thence I was conducted to a place expressly appropriated to the sale of human beings where, like the meanest animal of the brute creation, I was disposed of at public auction to the highest bidder."

By now Robert felt that death would be preferable to slavery, but he was determined nevertheless to seek his freedom. After receiving permission from his new southern master, whose name he did not know, to walk around the city, he spotted a sloop bound for Philadelphia and snuck on. Four days later, he was in Philadelphia. It would not be long before he was again betrayed—this time by a Quaker in whose boardinghouse he stayed for one night. Believing himself to be out of harm's way, he confessed everything to this man, who, under the pretense of consulting other Quakers, turned him in to the authorities for being a runaway slave. Robert spent nine days in jail before being slapped in irons and turned

over to the captain of another sloop headed to Charleston, where he was put up for public auction. His new master, Dr. Peter Fersue, a wealthy man who owned many slaves, was known to be less severe with his slaves than most landowners. Robert spent eighteen months as a house servant, but his frustration and anger at being held in bondage for no reason other than his color continued to grow. "Freedom, the gift of heaven, was too highly prized by me to permit anything of less importance to occupy my mind."

Robert finally discovered the chance to jump on yet another sloop, this time landing in Boston, Massachusetts, from whence he made his way to Charlestown, Lynn and finally Salem, where he had the opportunity to become a deckhand on a ship to India. That voyage lasted fourteen months, and others followed. In between, his life took another road, and Robert found himself living with an old woman and her three daughters, one of whom he married. Although still legally married to Alley, he despaired of ever seeing her again or even knowing if she was still alive. His new wife gave birth to a child, and Robert appeared to have found some degree of happiness, although there was rarely any money for luxuries. However, happiness was not to be found, even after all of his travails. When Robert returned from his latest voyage, he was hit with another kick in the stomach, for his wife told him coldly, "If I had never returned she would have been the last to lament." With no reason to stay in Salem, Robert left his home for Providence, Rhode Island, where the state legislature had abolished the auctioning of slaves in 1784, although rich merchants continued to use them for labor.

Robert spent a year working on assorted vessels and laboring on wharves, finally securing something of a regular job on packet ships that carried mail to and from British colonies. In Rhode Island, they ran from Providence to New York, and Robert was able to spend the next eight years working them. However, the image of Alley and his two young children had never left him. Now, twenty years later, knowing that his family would not recognize him, Robert decided to take passage on a ship from Providence to Baltimore, and from there he made his way to Georgetown, where he had been forced from his home and the arms of his family. There he began making inquiries into their whereabouts. But a reunion was not to be. Robert was devastated to learn that Alley's sufferings had been so great that she had taken her own life. She was the only woman he had ever loved. The children, unable to care for themselves and with no one to help, had died soon after.

*This was enough, yea more than enough, to fill to the brim the bitter cup of my afflictions! Afflictions which had more or less attended me through life. I then felt but little desire to live, as there was nothing then remaining to attach me to this world. It was at that moment that I formed the determination to retire from it, to become a recluse and mingle thereafter as little as possible with human society.*

Shunning the world that had betrayed him repeatedly, Robert returned to Rhode Island and built a small hut at Fox Point, living there until Tristam Burges, the wealthy former congressman who owned the land on which Robert lived, agreed to let him build a larger hut.

When Trumbull assembled his notes on Robert over a three-day span, he described him as six feet tall and heavy of build. His complexion was a shade lighter than most Negroes, and he had a thick, black beard. His quarters were small like a cell with a stone ceiling so low that one could not stand up straight. He slept on a bed of straw next to a crude fireplace and a block of wood served as a table. Robert's living quarters impressed Trumbull as gloomy, with a couple of openings for light that were closed with seaweed during the winter. Robert stayed in almost total darkness day and night, although he enjoyed reading. Trumbull gave him a Bible, only to learn that a woman in Providence had already given him one. Despite all that had happened to him, Robert never lost his faith in God. Henry Trumbull came away from his interview convinced that Robert was a happy man with his bed of rags and straw and a block of wood for a table. But there was a natural spring nearby and always the solitude. He contentedly ate from an iron pot with a piece of iron for his knife and a bucket for the spring water.

The story of Robert the Hermit was printed and distributed as a small booklet by Trumbull and sold for twelve and a half cents. Town fathers in Seekonk and neighboring Rehoboth, Massachusetts, took an interest in him and made regular checks on his well-being. After he became ill and it was evident that the end was near, they made daily pilgrimages to his hut and took care of the small expenses of his funeral, removal and burial.

Robert died as he eventually lived life—in peace.

# CHRISTIANA BANNISTER

Thousands of people crowded into downtown Philadelphia for the 100th birthday of the United States of America. It was May 10, 1876, and President Ulysses S. Grant had opened the first World's Fair at nine o'clock that morning on 236 acres of land at Fairmount Park. The Civil War had been over for a mere eleven years and the Emancipation Proclamation two years longer than that. Of the numerous art exhibits in Memorial Hall, which was built for the exposition and served as the city's art museum until 1928, only two were from African Americans. One was a sculpture of the death of Cleopatra by Edmonia Lewis; the other was a painting depicting sheep along the branch of a creek with hills and widespread branches, called *Under the Oaks*, by Edward Bannister. When it came time to present the awards for paintings, Edward Bannister strode proudly to the stage to accept his prize.

The officials were stunned that a black man was the winner and even questioned him about it. But no manner of inquisition could deter the fact that this New England artist had walked away number one.

Born in Nova Scotia, Canada, in 1828, Edward had never taken a formal art lesson. Throughout his long life, he attributed his artistic success to his religion and God. Although this was admirable, the real reason he was able to spend a lifetime painting was due to his marriage to a woman of mixed Native American and African American heritage, a divorcée named Christiana Carteaux. Were it not for her support and success as a businesswoman, Edward would not have become one of the country's best-known and accomplished artists. This is her story, not his.

The only known portrait of Christiana was painted by her husband, Edward. *Courtesy of the Newport Art Museum, Newport, Rhode Island.*

Christiana was born to John and Mary Babcock of the Narragansett Indian tribe in North Kingstown, Rhode Island, in 1819, which made her nine years older than Edward, who was not her first husband. She had married a man named Desiline Carteaux, who made a considerable living as a clothes dealer in Boston. Edward Bannister was hired as a barber in 1853 at one of

the hairdressing salons Christiana owned in Boston. In 1857, they married, and Christiana immediately told him to quit the hairdressing business and concentrate on painting. She had seen his work on display at the Boston Art Club when he was mainly turning out works with biblical themes, portraits, landscapes and seascapes, works that are, sadly, lost. Christiana afforded Edward the best opportunity of his life because he had not been able to study formally in a school due to his color.

Both Edward and Christiana were strong abolitionists and supported any antislavery movement they could find. In 1864, she set up a fair aimed at raising money for black soldiers who were being paid much less than white soldiers despite fighting the same Civil War.

A twenty-five-year-old fast-rising soldier named Robert Gould Shaw, from a wealthy Boston family, had become a full colonel in the Civil War after being placed in charge of the Fifty-fourth Massachusetts Volunteer Infantry Regiment, which was later the basis for the movie *Glory*. Although white, Shaw was pleased to head up the black regiment, and Edward was commissioned to paint his portrait. On July 18, 1863, while leading a charge at Fort Wagner on Morris Island in South Carolina, Shaw was struck by several bullets and killed instantly. Although no one seems to know where Bannister's original portrait is, memorials to Shaw are throughout Boston. Among them is a bust by the very person whose sculpture was displayed at the 1876 Centennial Exposition—Edmonia Lewis—and the famous Robert Gould Shaw and Massachusetts Fifty-fourth Regiment Memorial by Augustus Saint-Gaudens, located at Beacon and Park Streets in Boston.

For two years after their marriage, Edward and Christiana lived with Lewis Hayden, an ex-slave and one of the best-known antislavery activists in the country. His downtown Boston home was a station on the Underground Railroad and was usually filled with antislavery workers and fugitives making their way from the South to Canada. Hayden had escaped from Kentucky in 1844 and eventually settled in Boston, where he began making speeches that caught the ears of people like the Bannisters. Hayden was friends with Massachusetts Governor John Andrew and helped him form the Fifty-fourth Volunteer Infantry Regiment.

Following the Civil War, Christiana, who was also called "Madame," opened a hair salon in Providence, where she was affectionately labeled a "hair doctor," promising the rebirth of one's hair and the restoration of the original hair color.

While Christiana was busy building her successful business, husband Edward was painting at his studio, first a small one on Dorrence Street and

then in the Butler Exchange Building in Providence. He was also helping to create the Providence Art Club in 1880, a picture-perfect row of buildings located on Thomas Street directly across from the First Baptist Church, founded by Roger Williams in 1638.

There were several good years for the Bannisters. Their financial success allowed them to spend time at a cottage on Narragansett Bay during the summers, act in community theatre and purchase a sloop yacht they called the *Fanchon*. A fanchon was a tiny bonnet made popular during the Victorian era and worn by ladies who wanted to appear well off yet discreet, although there is no record of the Bannisters using this to name their boat. Edward would spend hours on the bay sketching and painting some of his best-known works, like *The Beaches of Newport* and *Fort Dumpling in Jamestown*.

Although the fashionable ladies of the day made up a large portion of Christiana's clientele, she became dedicated to the poorer black women and led a fundraising effort to build a home where servants who could no longer work would be able to live. On April 16, 1890, her dream came true as a three-story building housing 12 women was opened on the east side of Providence and called the Home for Aged Colored Women. In her honor, the home was changed to Bannister House, and it is operated today at 135 Dodge Street with 95 residents and 135 employees.

When Christiana died in December 1902, she willed three of her husband's paintings to the Home for Aged Colored Women. They were Edward's painting of her (done in 1893), *A Road that Leads to a House with a Red Roof* and *Four Cows in a Meadow*.

Juanita Marie Holland wrote a book about Edward Bannister, in which she quoted him as saying that he "would have made out very poorly had it not been for her [Christiana] and my greatest successes have come through her."

Edward Bannister's style of painting was called Barbizon, which fell out of style in the late 1800s. Another problem facing the couple was Edward's apparent memory loss, likely dementia or Alzheimer's disease. He was unable to make a living painting and became even more involved in his church work. On January 8, 1901, he made his way to the Elmwood Avenue Free Baptist Church, which still stands today at Elmwood and Park Avenues in Providence, for a prayer meeting. Edward offered a prayer and then took his seat in the congregation when he suddenly felt faint. Sitting next to him was Deacon Knight, who helped Edward into an anteroom of the church, where he died at 8:35 p.m. Dr. E.H. Perry was called and pronounced him dead of heart failure. His body was taken to his home at 69 Wilson Street,

# A Cast of Unusual and Overlooked Characters

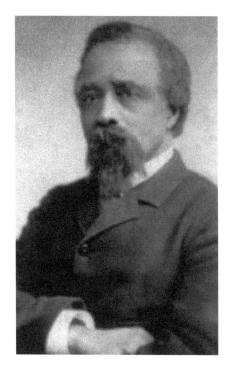

*Left*: Edward Bannister became an award-winning artist despite fighting discrimination over his being African American.

*Below*: Both Bannisters are buried under this rock at the North Burial Ground in Providence, but only Edward's name is on the stone. *Author's collection*.

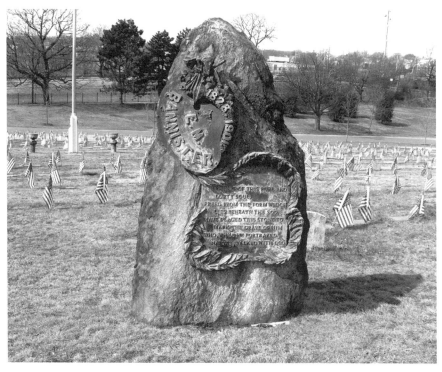

where Christiana was waiting. Edward Mitchell Bannister was dead at age seventy-two. His friends in the arts community bought a large rock, on the front of which was placed a palette with the inscription: "Friends of this pure and lofty soul, freed from the form which lies beneath the sod, have placed this stone to mark the grave of him, who while he portrayed nature, walked with God." To the rear of this stone is the grave of Edward's brother, William, who had died in 1873.

Now Christiana was alone at age eighty-one. They never had children. No longer able to work and with little money left, she moved into the home she had created, hoping to spend her final years there with her memories. Four months after establishing herself there, she began showing signs of delusional behavior and, according to people at the home, often became violent. She had to be moved to the state asylum for the insane at Howard in Cranston. Early published reports indicated that she had to be fed by tube when she refused to eat, but later she was said to be more agreeable to eating normally. Suffering from extreme exhaustion on December 29, 1902, Christiana died at the age of eighty-three. The cause of death was listed as senile delusional insanity and chronic nephritis, or kidney disease. At 11:00 a.m. on January 2, her niece, Miss Millie Babcock, also a hairdresser, held a prayer service for Christiana's friends at her home at 91 Hope Street in Providence. An hour later, there was a funeral at Elmwood Avenue Baptist Church, where Christiana and Edward had worshipped for many years. Christiana was then laid to rest with Edward. Although records at the North Burial Ground in Providence prove that she was interred in January 1903, her name has never been listed on the fancy stone, only E.M. Bannister's.

# DR. LUCIUS GARVIN,
## "EVERYONE'S DOCTOR"

S tanding on a doctor's office chair, the five-year-old girl didn't cry when the doctor stuck his needle into her arm and vaccinated her. In fact, the kindly doctor gave her a penny because she shed no tears and made the shot seem not so bad after all.

The year was 1918 and the location a house on Broad Street in Lonsdale, Rhode Island. The child was Millie and the doctor was Lucius Garvin, once a state governor and medical examiner and now a state senator, a post he would hold for the rest of his long life.

Dr. Garvin also made house calls, usually on his bicycle, and was known to rest on the couch in patients' homes if they were very ill or if a baby was due so that he could keep a watch on them throughout the night. Then he would go home to his second wife, who was blind, and care for her. When he wasn't feeling well, she would stay next to him throughout the entire day to make sure he was okay. Mildred Ehrenfried of Lewiston, Maine, grew up in Cumberland and remembered "an oldish man wearing a baggy linen suit and riding around town on a bicycle."

The story of Dr. Garvin is one of compassion, uphill struggles, tragedy and service to everyone.

Lucius Fayette Clark Garvin was his full name, and he came not from Rhode Island but Knoxville, Tennessee, where he was born on November 21, 1841. His father, James, was the librarian at East Tennessee University (today the University of Tennessee) but died of typhoid fever when Lucius was only four and a half years old, so his mother, Sarah, packed up him

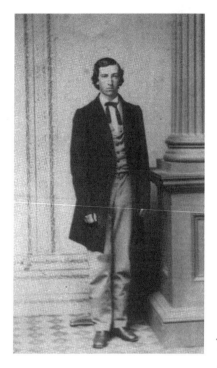

Lucius Garvin as a student at Amherst. *Author's collection.*

and his brother James and moved to Greensboro, North Carolina, where she became a teacher and eventually remarried and bore two more children.

Lucius was attending Amherst College when the Civil War broke out, and upon graduating from Amherst in 1862 he enlisted in Company E, Fifty-first Massachusetts Volunteer Infantry. His stepfather and brother had left North Carolina and fled to St. Louis to avoid the draft while his mother moved to Enfield, Massachusetts, with her two small children. While on active duty, Lucius was stricken with malaria and spent the rest of his enlistment in the hospital, finally being mustered out on July 27, 1863. It was during his time in the hospital that he decided on a career in medicine. Graduating from Harvard Medical School and training at Boston City Hospital, he was offered a post to practice medicine from the Lonsdale Company in Cumberland, Rhode Island, which he was to do for the next fifty-five years.

One of the perks of being in charge of medicine for the Lonsdale Company was a large house on Broad Street. Dr. Garvin needed a large house, because in 1869 he had met and married Dr. Lucy Southmayd, eight years his senior and a resident physician at Mount Holyoke Seminary in Massachusetts. This home housed his mother, Lucy's two children, a servant (Elizabeth Harris, who helped run his household) and eventually three young daughters, Ethel, Norma and Florence.

On the cold night of January 18, 1893, Dr. Garvin was awakened by the cries of neighbors who had heard or witnessed the horrific crash of a train and a horse-drawn sleigh filled with twenty-four singing revelers at the crossing on Mill Street across from the Ann and Hope Mill near his home. Eight people were killed and the others were injured, some critically. By now, Dr. Garvin had become one of the state's medical examiners, and he rushed to the bloody scene to care for the survivors. He quickly ordered

other doctors who had converged on the scene to help him bring the injured into the train depot, where they could be cared for out of the elements. It was a heroic action on his part, and his name was mentioned in the grisly details that appeared in the newspapers for several days.

A story that did not appear in the papers but was never forgotten concerned a large German shepherd dog named Prince. The dog lived near Dr. Garvin and was romping with his master, John Dawber, and his friend, Fred England, in a field near Robin Hollow on a warm summer day in 1895. While retrieving a ball thrown by John, Prince ran over an iron post hidden from view in tall grass, tearing open his belly and causing John and Fred to panic. They carried the heavy animal to Dr. Garvin's office nearly a mile away because they knew that Dr. Garvin could cure anything. Although reluctant because of the possibility of a dog bite, Dr. Garvin sewed up the dog's stomach, saving Prince's life. Soon, Prince's wound was healed and he was running after sticks again, having forgotten the iron pipe, just as Dr. Garvin had "forgotten" to charge the boys his usual fifty-cent office fee.

# TRAGEDIES

The first of the tragedies that were to test Lucius Garvin's faith occurred on January 20, 1898, when his wife Lucy died. For nine years he grieved, taking care of others while he was being cared for by his three daughters. In 1907, he met a young blind woman from the Perkins School for the Blind in Watertown, Massachusetts. Sarah Emma Tomlinson and Dr. Garvin were married on April 2 and settled in at 572 Broad Street. They eventually had two sons, but Dr. Garvin's older daughters, especially Norma, were embarrassed that their new mother was blind, even though she was a friend of Helen Keller, who had been gaining recognition on her own as an advocate for the disabled and who visited the Garvin home when she appeared before an audience in Providence. Sarah was much younger than the girl's mother. In fact, she was three years younger than Ethel, Dr. Garvin's oldest daughter, one year younger than Norma and three years younger than Florence. Although the daughters tried to support Sarah, especially because she was blind, it was Norma—already said by family to be unstable—who had the toughest time. She did not want anyone to know that she had a blind stepmother almost the same age as she was.

On November 21, 1912, Norma set out for Providence and the meeting of a women's club, at which there was to be a speaker she admired. The hour was late when the Garvins became alarmed, but no one was prepared for what happened next.

At 7:00 a.m. on November 22, Thomas Grimley of Lonsdale was walking along the riverbank of the Blackstone when he spotted a woman's hands in an uplifted position beneath the water's surface. He knew right away it was Norma because her hat and purse had been found on the riverbank. The family had feared the worst, and their fears were realized with the discovery of the body. Medical Examiner Marshall viewed the body after it had been brought to the top of a hill and confirmed that it was Norma and that she had taken her life. He ruled death by drowning due to temporary mental aberration. No one in the Garvin family made any statement. They conducted a wake at their home the next afternoon and then a private burial at Swan Point Cemetery in Providence.

Dr. Garvin managed to maintain a lively practice and write about health hazards in Lonsdale, such as the high infant mortality rate, which he attributed in part to the fact that mothers had to stop breast-feeding in order to get back to the mill and work. He sought to gain better sanitation in the home after learning that both children and adults drank from the Blackstone River, which ran near his home and through the town and contained "many impurities" thought to be the cause of many illnesses, including tuberculosis. In the Blackstone Mill, he counted thirty-six serious injuries in his first five years there caused by uncovered gears or pulleys. The most urgent need, according to Dr. Garvin, was lowering the number of hours children were forced to work, even though it was illegal for a child to work under the age of twelve. Some of the serious wounds were to kids, ages eight to eleven, he noted. It was a busy life for the doctor, and between 1867 and 1921 he handled more than one thousand obstetric cases. He performed surgery in his office at 577 Broad Street, being roused at all hours of the night to perform a variety of treatments because there were no phones in the early part of his career. Dr. Garvin preferred to perform the surgery himself, saying, "There was no hospital to which we could send our surgery cases, and had there been one near me, I no doubt would have held close to the theory generally held in the profession that it was not wise to send a patient to such an institution for fear that he would not receive the right attention." He also walked to the homes of some patients, and as late as 1921, he was the only doctor in the state who did not use an automobile. His office was open seven days a week, often until 8:00 p.m.

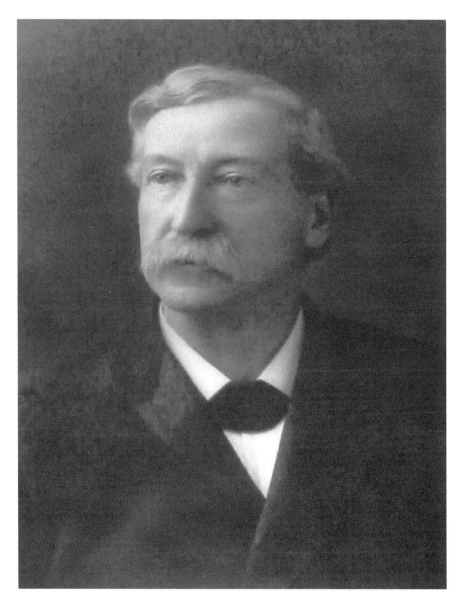

The formal portrait hanging in the Garvin Elementary School in Cumberland, Rhode Island. *Author's collection.*

## POLITICAL LIFE

Lucius Garvin first voted for Abraham Lincoln, a Republican, in 1864, but soon changed his party affiliation to Democrat and began a lifetime of working for better living conditions in Rhode Island. In 1883, he was appointed to the general assembly, filling a recently vacated seat. He immediately sponsored a bill changing the constitution, which lost by a vote of forty-eight to seven, the first of many defeats at the hands of the majority Republicans. When Dr. Garvin was elected on his own in 1884, the leaders in the Republican Party in Rhode Island were Senator Nelson Aldrich, said to be the most powerful man in the country; *Providence Journal* newspaper owner Henry B. Anthony; and Charles R. Brayton, known as "Boss" Brayton. Dr. Garvin was very popular in Cumberland and was elected to the state legislature sixteen times, including three as a senator. He also tried four times to get elected to the U.S. Congress and finally in 1901 decided that it was time to run for governor of Rhode Island. Anthony denounced Garvin and predicted a win for incumbent William Gregory, which proved to be correct. Gregory died soon after taking office and was succeeded by another of Boss Brayton's men, Charles Dean Kimball. Refusing to debate Dr. Garvin, he preferred to remain silent and rely on the party leaders to keep him in office.

Dr. Garvin wondered how anyone could vote for a Republican, asking, "How is it possible that patriotic citizens of average intelligence could cast a vote for republican candidates for General Assembly?" Apparently his message got through to those voters because he was elected governor of Rhode Island by a comfortable margin, although, as he was soon to find out, it was nothing more than a ceremonial job and Republicans still ruled the roost. Following Dr. Garvin's victory, Boss Brayton said, "What are they crowing about? The democrats didn't do anything but elect a governor who can't do anything but sign notaries' commissions and a lieutenant governor who can't do anything." When the new governor spoke in the general assembly, many in attendance would go out for a smoke. Just before Dr. Garvin's election, the Republican-controlled senate took appointment power away from the governorship and gave it to the senate, fearing that Democrats could win. Dr. Garvin was stripped of veto power. Thus, by the public, which had little knowledge of the shenanigans, Dr. Garvin was looked upon as a do-nothing governor. Dr. Garvin took advantage of his office, however, and made many speeches condemning the Republicans, even accusing them of taking payoffs. In return, the *Providence Journal* editorialized, calling Dr. Garvin "the most lilli-livered Executive in the United States."

# A Cast of Unusual and Overlooked Characters

At the dedication of a memorial to Rhode Island soldiers who died at Andersonville Prison in Georgia during the Civil War, Dr. Garvin saved the life of a four-year-old boy who had suffered a broken leg in a carriage accident and was bleeding to death. He set the boy's leg properly and the youth survived. As governor, Dr. Garvin was allotted time to speak at the ceremonies. He remarked:

> *The memories aroused by this spot are sad ones, but the occasion calls for the deepest gratitude. We may indeed be thankful to meet here in an unbroken nation, as brothers once estranged, but now knit together in the bonds of a common history and a common destiny. Those of us, who on either side participated in the Civil War look back upon it as a horrid dream. The four bloody years serve to remind us how small an advance our boasted civilization has made from barbarism. How little indeed we have risen above the brutes. Although we do not yet see it to settle the dispute by the method of war is to place all who are responsible therefore of a level with the wild beasts.*

The margin was small, but Lucius Garvin was reelected to a second one-year term as governor of Rhode Island in 1903 and immediately continued his attack on corrupt Republicans. William Jennings Bryan put his name before the public as a presidential candidate to succeed Theodore Roosevelt, but Garvin turned it down. In 1904, he told a gathering at a YMCA dinner that "public life is deteriorating, public servants are yielding more and more to the greater temptations put before them." Still, the Republicans remained strong and their handpicked candidate, George Utter, defeated Dr. Garvin in the 1904 gubernatorial election. He would lose again to Utter in 1905. Dr. Garvin was named as a delegate to the Bull Moose Party at the convention in Chicago in 1912 but did not win another election until 1920, when he was elected to the state senate from Cumberland. He was seventy-nine years old. He continued making house calls between senate duties but was now suffering from heart disease. In April 1922, he sponsored a bill in support of a forty-eight-hour workweek. The bill went to committee.

Lucius Garvin was not totally in the political wilderness. He continued to rail against the Republicans and caught the ear of famed muckraker Lincoln Steffans, who visited him in 1903, listening to the beleaguered chief executive talk about how helpless he was and what was wrong with Rhode Island. Steffans, a San Francisco journalist and editor of *McClure's Magazine*, penned a series of articles called "The Shame of the Cities," which proved so popular that he went on a nationwide tour telling his audiences about

Vaccination certificate signed by Dr. Garvin after vaccinating the author's mother in 1918 and giving her a penny for not crying. *Author's collection.*

"the ethical paradox of private interest in public affairs." When he visited with Dr. Garvin, he described Rhode Island as a state for sale, cheap. Even Mark Twain, who lived in neighboring Connecticut, named Garvin on his imaginary people's lobby team.

At 4:00 p.m. on October 2, 1922, the eighty-one-year-old Dr. Garvin was in his Broad Street office and asked his wife Sarah for an ice bag. Although blind, she was constantly at his side and knew where everything was in that office. As Sarah handed him the ice bag, she heard him fall and immediately knew what had happened. Dr. Garvin had been reaching into his medicine cabinet to get a stimulant for his weakened heart when he was stricken. He died almost instantly and was buried beside Norma and his first wife Lucy at Swan Point Cemetery in Providence.

Among the many eulogies expressed at Dr. Garvin's passing, Mayor Joseph H. Gainer of Providence spoke most eloquently: "In the death of Dr. Garvin the state loses a most valuable citizen. He exemplified the belief in serving and he has devoted himself to the betterment of the conditions on his fellows. Governor Garvin was an honest, sincere, forward looking citizen. Rhode Island will miss him."

This was not the end of the story of Lucius Garvin, at least not the happy conclusion to a full life. Florence, his youngest daughter, moved to Delaware and ran for Congress in 1924. She was also a vice presidential candidate on the United States of America National Party ticket in 1932.

When Dr. Garvin died, the home in which he and Sarah had lived on Broad Street did not belong to him. It was the property of the Lonsdale

Company, and as long as he was employed by it the house was his to live in. His passing presented a problem for Sarah, who was forced to move to one of the small brick houses at nearby Blackstone Court, accommodations which were not even close to the quality of living she had been used to. The same little girl who was given a penny by Dr. Garvin when he vaccinated her recalled in her nineties watching the blind Sarah being led by the hand up and down Blackstone Street to visit family. Soon she was forced to move again, this time to a small apartment in Pawtucket, where she stayed until 1948, when she moved in with her daughter Florence, who had never married. They migrated to Ohio, then Maryland and finally to Pasadena, California, where they lived until December 10, 1960. Sarah had become ill and died on that date at Huntington Memorial Hospital at the age of eighty-seven. She was buried in Swan Point Cemetery in Providence, Rhode Island, with her husband, his first wife Lucy and her stepson, who had died in 1938 at the age of twenty-eight.

# A GOVERNOR'S LIFE

W hen Rhode Island's Norman Stanley Case was selected as president of the 1928 Governor's Conference, the man chosen as secretary was New York Governor Franklin Delano Roosevelt. Case was reelected in 1930 and 1932, although he did not serve for long after that because he was defeated in his bid for another term. Thus began a long friendship that lasted until FDR's death in April 1945.

Case was lieutenant governor when longtime Governor Aram Pothier died in office in February 1928, but his life was much more than that. He was a soldier in World War I, appointed as Rhode Island district attorney in 1921 by President Warren G. Harding, had drinks with President Calvin Coolidge during Prohibition and started a friendship with then New York Governor Franklin Roosevelt. He was also very much part of the creation of Rhode Island's State Police and the development of land at the Hillsgrove section of Warwick that became the state's main airport.

## A LOCAL BOY MAKES GOOD

Norman Stanley Case was born in Providence on October 11, 1888. He graduated from Classical High School, where he was a standout baseball player; graduated from Brown University in 1908; studied law at Harvard University; and eventually graduated from Boston University Law School in

1912. He and some of his classmates joined the Massachusetts National Guard, and after graduation, he transferred to the Rhode Island National Guard. He served at the Mexican border from June to October 1916, rising to the rank of captain of a machine gun company when the United States entered World War I. Eventually, he became a colonel in the 316th Cavalry in the U.S. Army and was a member of the Rhode Island Soldiers Bonus Board.

Case had been practicing law in Providence and serving on the city council from the Ninth Ward during his time overseas, which endeared him to citizens of Rhode Island and gained him a reputation as a patriot concerned with the people.

When President Harding named him district attorney for Rhode Island in 1921, he stayed at the post until 1926, when he ran for lieutenant governor, was elected and sworn in on January 9, 1927. Little did he know that within thirteen months he would be the governor of Rhode Island. On February 4, 1928, Governor Aram Pothier died suddenly, and five days later, Norman Case was sworn in to replace him. Case was reelected twice, beating Alberic A. Archambault on November 6, 1928, for a full two-year term and again in November 1930, when he defeated Theodore Francis Green.

Norman Case married Emma Louise Arnold on June 28, 1916, and they had three children: Norman Jr., John and Elizabeth, also called Beth. Emma was Norman's first cousin. A doctor was consulted, and the young couple were given a green light to marry. Norman Jr. became a lawyer after graduation from Brown. John, also a Brown graduate, died in World War II, and Beth graduated from Brown just like her father and worked for twelve years in foreign service during the war before marrying Frank Creed, who was employed with the government of Canada, and settling in Mahone Bay, Nova Scotia. Only a child when her father became governor, Beth recalled her fondness for Eleanor Roosevelt, with whom the Cases had become friendly during the time both Norman and FDR were governors. Roosevelt was governor of New York and Case was chief executive of Rhode Island, and their friendship began at the Governor's Conference in 1928. Although Case was a Republican and Roosevelt a Democrat, Beth said, "They didn't always agree but seemed to hit it off and stay in touch all through the White House years."

Case liked to brag about Rhode Island, and on September 30, 1930, he sent the following note to Roosevelt: "Accompanying my warmest regards and best wishes I am sending to you by this post a copy of *The Book of Rhode Island*. A glance at its pages, I believe, will give you a vivid and pleasing impression of Rhode Island's commercial, educational and social life."

To which Roosevelt replied from the governor's mansion in Albany, "I am delighted to have *The Book of Rhode Island* and I am ever so grateful to you for sending it along to me. I shall enjoy reading it in some detail at the very first opportunity." And so it went for years from Albany and then the White House to Norman Case, both at the Rhode Island State House and then the Federal Communications Commission, which Roosevelt created and named Case as its first member.

## MEETING OL' CAL

When Norman Case became governor upon the death of Aram J. Pothier in February 1928, he made an appointment to travel to Washington to visit with President Calvin Coolidge. His intention was nothing more than paying a courtesy call on the man who had succeeded to the oval office upon the death of Warren Harding in 1923. Case was told by a staff person that he had exactly five minutes to talk with the president. When he was ushered into the president's office, he was greeted stiffly by the chief executive and told to take a seat.

"What can I do for you?" asked Coolidge.

"Nothing, Mr. President," Case answered. "I thought a New England governor should pay his respects to a New England president."

"You mean you don't want nawthin'?"

"No sir."

After hearing that Case wasn't looking for a handout, the president chatted with him for a half hour.

Norman Case Jr., a retired attorney living in Bethel, Vermont, chuckled as he told that story and added another involving his father and Coolidge.

"Father went to see Coolidge in a hotel in New York City. A Coolidge aide said, 'Perhaps the governor would like a drink.' Coolidge, a teetotaler, took out a key, unlocked a satchel and brought out a bottle. This was during Prohibition." Another man was in the room, and when the aide asked Coolidge if Mr. X would like another drink, the president declared, "He's had his!"

For several years, Norman Case and his family lived in what they called their summer house on Narragansett Terrace in East Providence. Most of the homes in that area were built in the 1890s, were two stories high, had wraparound porches and cost about $700. Those houses nearest to

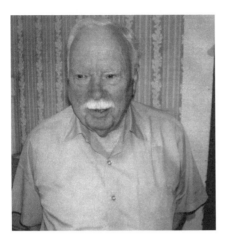

Norman Case Jr. was an attorney who lost his sight to illness when he was a child yet practiced law for more than sixty years. *Author's collection.*

Narragansett Bay were known as the fifty-cent houses because land cost fifty cents for a single lot.

The paperboy in that area was Godfrey Allen, who recalled during a 1992 interview with the *Providence Journal* that his best customer was Governor Case. "The governor's maid would come to the door and say to take 'em up and put 'em on the bed." If the governor was awake, he would give Allen fifty cents, which included a five-cent tip. The boy was thrilled because in those days a nickel could buy an ice cream cone.

Case was well liked by the people of Rhode Island, who threw a testimonial in his honor at Crescent Park, a centerpiece of East Providence, and presented his wife Emma with a new 1928 Dodge sedan. Although the car was for the governor, it was given to Mrs. Case lest it give the appearance of a bribe. The governor actually had a Packard furnished by the state and a driver named Walter Wallender, who also drove the children to school because of kidnapping threats. A doctor who sported license plate number one offered it to Governor Case, who turned it down, instead taking the number 200,000, the largest number in the state at that time.

In 1938, a hurricane swept through southern New England, killing 125 people and wiping out thousands of houses, including the Case's summer home.

When Franklin Roosevelt was still governor of New York, he and the Cases would get together whenever possible. On March 24, 1932, Roosevelt's last year in Albany, Norman Case attempted to pay a call on his friend only to find him gone to his summer house at Hyde Park, New York. "Just so as not to pass through Albany without paying my respects I expect you are going home for Easter. Hope you are all OK, Hastily, Norman S. Case." The letter was written from the DeWitt Clinton Hotel in Albany.

On February 18, 1932, Roosevelt sent Case a picture of them taken during a visit with a note saying, "I think this picture is quite a good one and I thought perhaps you might like to have it. We all enjoyed your visit so much and I hope I shall soon see you again. Yours Very Sincerely, Franklin."

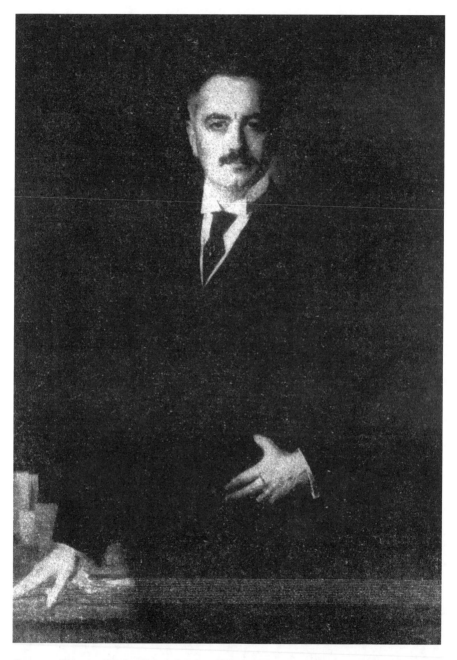

Governor Norman Stanley Case, who once defeated Theodore Francis Green and was a great friend of FDR. *Norman Case Jr. Collection.*

Case immediately wrote back, "This picture will serve as a constant reminder of the very pleasant visits I have had at the Executive Mansion in Albany and the friendship with the present governor of the state of New York and his wife which Mrs. Case and I most sincerely cherish."

When Norman Case decided to run for a full third term, he found himself locked in a battle with Theodore Francis Green, a Roosevelt Democrat who hoped to run into the statehouse on the strength of the popular New York chief executive and in a backlash against the Depression-mired Herbert Hoover.

Case had received a congratulatory letter from Hoover on November 25, 1931, praising the state's unemployment relief efforts. The state had mounted community chests to combat the unemployment rate and to provide relief to indigent Rhode Islanders. The state's municipalities were allowed to borrow chest money from the state at 3 percent. The general assembly approved Case's bill that appropriated $1.5 million for unemployment relief to those cities and towns that needed it. In a letter to Hoover, Case said it proves that "Rhode Island will provide for its own." The bill had been opposed by Theodore Francis Green and it became a campaign issue in the 1932 gubernatorial race.

## DEFEAT AND A NEW LIFE

In 1931, the nation's biggest problem was the Depression. In Rhode Island, the issue was whether the state or local communities should be in charge of relief to the thousands who were in need.

Case said that "it was the duty of local communities to care for their own needy and jobless." He wanted cities and towns to pay for that relief and then have the state reimburse them by lending money at 3 percent interest. Theodore Francis Green strongly disagreed. Case had gone to the general assembly with his proposal and saw it approved. Green's contention was that it would increase taxes on the local level, and he instead proposed increasing consumer purchasing power by hiking the minimum wage. His campaign slogan in the race for the statehouse was "humanity first," and he tied Case to Hoover and the Depression. Case also ignored Green's call for a debate on the issue, and it was a costly refusal, for Green defeated him in the general election by 31,036 votes in what the *Providence Journal* called "the greatest upset in history." Case still had a strong voter base and, in fact, received 3,000 more votes than he had

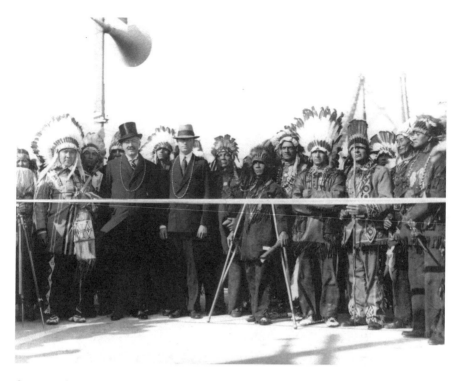

Governor Case (in the top hat) at the ribbon-cutting of the Mount Hope Bridge in Bristol, Rhode Island, on October 24, 1929. *Norman Case Jr. Collection.*

when he won the last election, beating Green, but this was a vote for Democrats and Roosevelt and a backlash against the one-term Hoover.

Norman Case was out of a job, and his old friend Franklin was now president of the United States, but it would not be long before the former Rhode Island governor was living and working in Washington and sleeping in the White House.

In April 1932, well before the general election that saw Roosevelt win the White House, he and Norman Case paid a call on President Herbert Hoover. Although the Depression was sweeping the country, Hoover had no hint that he could lose and kept both Roosevelt and Case waiting outside the Oval Office for some time. Both men were left standing, something that was very difficult for the crippled Roosevelt, even with the help of his strapping son James, who usually helped his father stand. As time went by, Roosevelt was getting uncomfortable, and Case asked an attendant if he would get the New York governor a chair.

"I'd like to but it would mean my job," answered the aide. Whereupon Case simply walked to another part of the outer office and got the chair for his friend Franklin.

Following Hoover's defeat at the hands of Roosevelt, Case received the following letter from the executive mansion in Albany.

> *My dear Norman,*
>
> *That is a mighty nice note of yours. On election night I said to Mrs. Roosevelt "If any Republican Governor pulls through I hope it will be Norman Case."*
>
> *It would have been a real delight to have you and Mrs. Case at the White House in your official capacity—now you must come just the same—and I will promise you that things will not be as regal as they were when we were all there together in April.*

Roosevelt was referring to the uncomfortable and annoying way they were treated while waiting for Hoover to see them. The sour look on Hoover's face as he rode in the limousine to the inauguration with Roosevelt says it all.

## THE FCC AND WASHINGTON, D.C.

The following dispatches sum up the next phase of Norman Case's life and his move from Providence and East Providence to Washington, D.C. He would spend the next ten years working in the nation's capital as a member of the newly created Federal Communications Commission.

Created by the Communications Act of 1934, the FCC's job was to regulate all nongovernment use of radio—and later television and cable—and hold the power to issue licenses for broadcasting. Upon approval of the Senate, each commissioner originally served a seven-year term until either reappointed by the president or replaced. Roosevelt reappointed Case once and President Truman did not, although in naming the former governor of Vermont, William Henry Wills (1882–1946), to take his place Truman commented at a press conference on June 15, 1945, "It's just a case of one Republican taking the place of another. Vermont is surely a Republican state so they couldn't accuse me of playing politics up there." Wills only served on the FCC for nine months before dying at the age of sixty-three while presiding over a hearing on March 6, 1946.

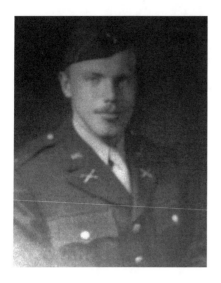

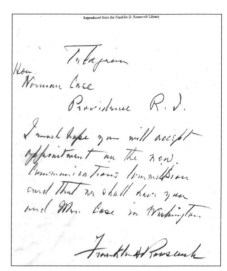

*Above, left*: Lieutenant John Case was killed in action during World War II. *Norman Case Jr. Collection.*

*Above, right*: The handwritten note from FDR asking Case to become a member of the first FCC. There exists at Hyde Park many letters exchanged between the two old friends. *Courtesy of the FDR Library, Hyde Park, New York.*

Governor Case settled in Washington, D.C., following his appointment and seemed to enjoy his work on the new commission. His son, Norman Jr., was a practicing attorney in Rutland, Vermont, but would eventually get a job in the law department of the FCC. Norman Jr. was ineligible for the service because of blindness, but he worked as an attorney both in Washington and his home in Bethel, Vermont, for sixty years. When he graduated from Brown University in 1940, he was the first blind man to receive Phi Beta Kappa. He then went on to Yale Law School. Norman's daughter Beth was living and working in Washington, D.C.

There was a third child, John Warren Case, who graduated from Brown University in 1942. He had been interested in the military and, when he was a freshman, joined the Citizens Military Training Corps in Coast Artillery for a summer at Fort Adams in Newport. He then switched to Field Artillery Training, spending summers at Fort Ethan Allen in Vermont. Because of his military background, he received a commission as a second lieutenant in April, when he was a senior and had turned twenty-one, so he never personally received a diploma. John sailed with the 29th Division, a part of the National Guard, for England on October 5, 1942, and sadly

never saw his family again. During the siege for Brest in France, which lasted from August 7 to September 19, 1944, he was a forward observer with the 29th Division, 143rd Field Artillery, when a mortar shell struck and severely wounded him. John was taken to a hospital in England, where he succumbed to his wounds on September 19, 1944, the date credited with the end of the battle for Brest. It had been one of the fiercest fights during Operation Cobra, and the German infantry had been well entrenched before finally being routed. More than one thousand men were killed during Brest, and Case was one of four thousand wounded. He is buried in the American Cemetery at Cambridge, England. For months his father wore black. His mother, Emma, took to her bed for two weeks. President Roosevelt expressed his sorrow in a letter to Governor Case. It would be the last known correspondence between the two old friends. Roosevelt died on April 12, 1945, while vacationing in Warm Springs, Georgia. Norman Jr., who happened to be in Washington visiting his parents, remembers riding home with a man named Clarence, who was in charge of handling messages for the FCC, when he heard the news of Roosevelt's death.

When he was not reappointed to the FCC by President Truman, Norman Case practiced law for a time in Washington and then came home to Rhode Island for the last time. He settled in Wakefield and opened a small law practice, which he worked at for the remainder of his life. On October 9, 1967, after battling several ailments including kidney failure, he passed away at his home. Two days later, he was buried in Swan Point Cemetery in Providence on what would have been his seventy-ninth birthday.

# RHODE ISLAND'S THIRD CONGRESSMAN AND "THE STAR-SPANGLED BANNER"

R hode Island has two members of the House of Representatives. Most other states have more, but there once were three Rhode Island men in the national House, three congressmen and one of them was responsible for "The Star-Spangled Banner" becoming our national anthem.

His long-forgotten name is George Francis O'Shaunessy, and he was born in Galway, Ireland, on May 1, 1868, to poor parents who came to America and settled in New Jersey, where his father Stephen managed to make a living as a clothing merchant. George attended parochial schools in New York City and then Columbia Law School, where he graduated in 1889. George was admitted to the New York Bar right away and by 1904 was appointed deputy attorney general of the state.

On a business trip to Rhode Island in 1907, George met a girl named Julian Keily, with whom he fell in love and married. They decided to live in Rhode Island after Julian's mother died, and George was admitted to the state bar and opened a law firm, O'Shaunessy, Gainer and Carr. Eventually, it would be O'Shaunessy and Cannon, and today there are still Cannons practicing in Providence.

In 1909, after expressing an interest in the Democratic Party, George ran for state representative from the Ninth District and in 1910 ran for and was elected to the First Congressional District, making up much of Providence and surrounding communities. Rhode Island had three congressional districts from 1913 to 1933, when a census finally eliminated it. The third district covered the Pawtucket area and sections

of northern Rhode Island. When George O'Shaunessy took office on March 4, 1911, there were still just two, but the third was created one term later to cover Woonsocket. In fact, congressmen were even elected at large from 1790 to 1843.

George was the only Democrat serving Rhode Island in the Congress but he managed to get reelected until 1918, when he left the House and ran for the Senate against incumbent Le Baron Colt. He lost that election but was named collector of internal revenue for Rhode Island by President Woodrow Wilson, where he stayed until 1921. He again tried for the Senate but was beaten by former governor William Flynn and later twice refused the Democratic nomination for mayor of Providence. His political career was over, and he continued practicing law until he retired in 1931.

George O'Shaunessy was known as a dynamic speaker. He was six feet tall, handsome and passionate about his issues. None gained him more popularity than when, on December 6, 1914, he rose on the House floor to introduce a bill declaring "The Star-Spangled Banner" to become the United States national anthem. It was an appropriate time, he said, for the nation to give its official sanction to the selection of a poem by Francis Scott Key. Some of O'Shaunessy's colleagues were astonished that "The Star-Spangled Banner" was not already our national anthem. After all, it had been played and sung for decades and even introduced earlier by other congressmen. But no action had ever been taken because of where the tune came from. It was the same melody as an English drinking song called "Anacreon in Heaven."

One hundred years earlier in August 1814, the British captured Washington, D.C. Outside the city in Upper Marlboro, Maryland, Dr. William Beans and some of the villagers captured some British looters and brought them to the local jail, only to be overtaken by a large detachment of troops and themselves taken prisoner to the British flagship the *Tonnant*. Dr. Beans's friends hired a local lawyer named Francis Scott Key to work out a prisoner exchange, which he successfully did. However, the impending British attack on Baltimore and Fort McHenry forced the detention of Beans, Key and Colonel John Skinner, who worked with Key on the exchange. They were held under guard until after the battle, which began with a large American flag flying over the fort. The flag had been ordered to be as large as could be, and when it was finished, it measured thirty by forty-two feet. Mary Young Pickersgill and her thirteen-year-old daughter, Caroline, sewed the flag together on the floor of a brewery using

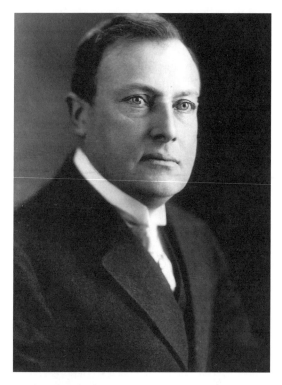

George O'Shaunessy portrait used in his campaigns for Congress when Rhode Island had a third congressman. *Author's collection.*

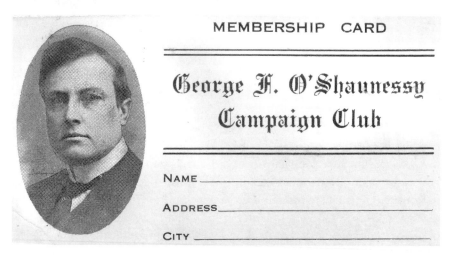

Campaign card handed out by O'Shaunessy and found in his desk at his Providence office more than fifty years after his death. *Author's collection.*

four hundred yards of quality wool bunting and cutting fifteen stars and eight red and seven white stripes into it. The flag today is in the Baltimore Flag House Museum. As daylight came, the three captives rejoiced that the flag was still there and the British had abandoned the attack. Key took an envelope from his pocket and, in a moment of inspiration, began writing a poem about the event, finishing it in his hotel room. A friend had it published under the title of "Defense of Fort McHenry," and soon it was being sung to the tune of "Anacreon in Heaven." In October, an actor performing it in Baltimore changed the title to "The Star-Spangled Banner." One of the copies that Key wrote is in the Library of Congress. Another remains at the Maryland Historical Society.

So now "The Star-Spangled Banner" was being sung everywhere. The United States was growing, wars were fought and the land expanded. George O'Shaunessy was the last person to introduce a bill creating a national anthem, but according to Dwight Miller, senior archivist at the Herbert Hoover Presidential Library, folders filed under "National Anthem" contained about 150 pieces of correspondence mostly against using the banner as the anthem. One telegram, according to Miller, read: "The President: The Star Spangled banner as a national anthem puts us to shame before civilization world. We look up to you to avoid this national embarrassment. Signed, The National Music Foundation."

Leading up to the Hoover administration was a trail of disappointment to O'Shaunessy and those who sided with him on the issue. When he introduced the bill on December 6, 1914, it was again referred to committee, where it died. It was the last of forty resolutions creating the national anthem. President Wilson ordered it played at all military functions. Again O'Shaunessy introduced the bill and the House passed it, only to see it die a quiet death in the heat of the U.S. Senate.

O'Shaunessy never gave up his quest. He retired to his home at 716 Elmgrove Avenue in Providence in 1931. Then came the news he had been waiting for. On March 3, 1931, a telegram was issued by the White House and signed by President Herbert Hoover. "The Star-Spangled Banner" officially became our national anthem. Francis Scott Key had been dead for eighty-eight years.

On November 3, 1934, George O'Shaunessy suffered a heart attack in his home and died there on November 27 at the age of sixty-five. Even today, he seems to be anonymous. He was buried in the only tomb at St. Francis Cemetery in Pawtucket, Rhode Island. The name on the tomb is Keily, his wife's maiden name. Nowhere is there a mention of O'Shaunessy.

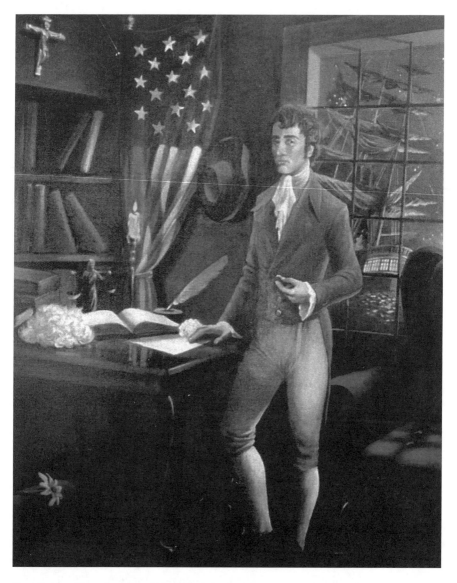

Francis Scott Key, who wrote "The Star-Spangled Banner." *Author's collection.*

# A Cast of Unusual and Overlooked Characters

On August 1, 1998, the Rhode Island General Assembly passed a resolution proclaiming each August 11 "Francis Scott Key Day."

*O say can you see, by the dawn's early light,*
*What so proudly we hailed at the twilight's last gleaming,*
*Whose broad stripes and bright stars thru the perilous fight.*
*O'er the ramparts we watched were so gallantly streaming?*
*And the rockets' red glare, the bombs bursting in air,*
*Gave proof through the night that our flag was still there*
*O say does that star spangled banner yet wave,*
*O'er the land of the free and the home of the brave?*

These are the words usually sung publicly, but Key wrote three other similar verses. You may sing them to the same tune.

*On the shore, dimly seen thro' the mist of the deep*
*Where the foes haughty host in dread silence reposes*
*What is that which the breeze, o'er the towering steep*
*As it fitfully blows, half conceals half discloses?*
*Now it catches the gleam of the morning first beam*
*In full glory reflects now shines in the stream:*
*'Tis the Star Spangled Banner! O long may it wave*
*O'er the land of the free and the home of the brave.*

*And where is that band who so vauntingly swore*
*That the havoc of war and the battle's confusion*
*A home and a country should leave us no more*
*Their blood has washed out their foul footsteps' pollution*
*No refuge could save the hireling and slave*
*From the terror of flight or the gloom of the grave:*
*And the Star Spangled Banner, in triumph doth wave*
*O'er the land of the free and the home of the brave.*

*O thus be it ever when free men shall stand*
*Between their loved homes and the war's desolation!*
*Blessed with vict'ry and peace, may the heav'n-rescued land*
*Praise the power that has made and preserved us a nation*
*Then conquer we must when our cause it is just*
*And this be our motto, "In God is our trust"*
*And the Star Spangled Banner in triumph shall wave*
*O'er the land of the free and the home of the brave.*

# A BRAVE DEED, A GREEN APPLE
# AND THE GARDEN OF EDEN

M etcalf Bowler was a rich man. He owned ships and had more than one spacious home in Rhode Island. He was probably a spy too, although for which side in the Revolutionary War was not quite clear. He was the Speaker of the House of Representatives in the colony of Rhode Island for nineteen years and a judge on the Supreme Court for six more, and one as its chief justice. And while all this makes for a successful and exciting life, his real love was cultivating his garden and plants at his country house in Portsmouth. He had one of the colony's first hothouses and owned exotic plants from throughout the world.

Bowler owned a variety shop on the west side of the Weybosset Bridge at the sign of the Queen's Head. This shop catered to many British soldiers as well as sympathizers. Just as many colonists came to buy, too, and no one truly knew where he stood during the early days of the Revolution.

Metcalf Bowler was born in 1726 in Newport, and when he was a young man, his father bought a house that was to become famous throughout the young nation as the headquarters of Count de Rochambeau during the war. Prior to its becoming Rochambeau's domain, it had been enlarged in 1759 by Bowler, who inherited it from his father. He created one of the city's most elegant homes, and even today it still stands as the Vernon House, which is privately owned.

Now to the title of this story: a brave deed, a green apple and the Garden of Eden.

Newspaper clippings depict the bravery, the ships and of course the green apple found today and cultivated throughout Rhode Island. *Mildred Laxton Collection.*

Bowler had taken his inheritance and built it into a fleet that brought back riches from the East India trade. The captain on one of Bowler's vessels returning from East India spotted a shipwrecked young man whom he quickly plucked from the sea. This man turned out to be a prince of Persia. The prince's father, eternally grateful for the safe return of his son, ruled in a Persian palace that had been built over what he said was once the Garden of Eden.

In addition to the house in Newport, Bowler had what has been called the most splendid garden in Portsmouth, along the Sakonnet River. Acquiring knowledge of husbandry, he also wrote a treatise on agriculture. So one can imagine his excitement when the Persian ruler presented to Bowler's captain a young apple tree in a porcelain pot, with the declaration that this was a true descendant of the Tree of Knowledge.

Placing the prized possession into his hothouse to protect it from any harm, Bowler retired for the night. In a dream, an angel admonished him to remove the tree from the hothouse to his outside garden, explaining that Rhode Island's climate was suitable and even better than Assyria's, from whence it came. True to the angel's promise, the transplanted tree grew and flourished, producing apples known today as Rhode Island Greenings, not to be confused with similar-looking Granny Smith's, which were created by Maria Ann Smith in Australia in 1867 when she was sixty-eight years old. Bowler beat her by a century. Legend has it that except for the site of the Garden of Eden and Rhode Island, no place on earth can produce the same flavor or grow them to the same perfection.

As years went by and the Revolution loomed over Rhode Island, Bowler began to make and manufacture Greening cider, a nectar so delicious that he named it Eden Champagne. Before his farm was destroyed by the British—despite his written pleas to people like the hated General Richard Prescott—he hosted a dinner party in honor of George Washington and the Marquis de Lafayette. On hand were Count de Rochambeau, Admiral Charles De Tiernay, Reverend Ezra Styles, Parson Dr. Hopkins and William Ellery. The Frenchmen were eager to taste some fine wine, and Bowler saw the chance to get some expert opinions about his cider. He prepared two bottles of the best French wine and twelve bottles of Greening cider. Placing three glasses before each guest, two filled with wine and the other with Greening cider, he asked each man to declare which he considered the best. Sipping all three, the connoisseurs pronounced Eden Champagne the best they had ever tasted in their travels around the world. Happily, Bowler confessed that they

were drinking cider, and at the end of the evening, the two fine French wines remained untouched and the twelve bottles of Eden Champagne had been drained dry.

In 1768, Bowler invited all of Newport to come to his home in town to celebrate the repeal of the Stamp Act. Surely, Eden Champagne was served.

# A REVOLUTIONARY WAR
# LOVE STORY

B attles raged throughout the East during the Revolutionary War, yet the
leaders managed to find time to relax at places like Hacker's Hall on
South Main Street in Providence. General George Washington had first
visited Providence on April 5, 1776, and, working closely with General Jean
Baptiste Donatien de Vimeur, Count de Rochambeau and his regiments and
the Marquis de Lafayette, secured liberty and justice for all.

The stories about the Revolution are familiar to many, but the drama
that unfolded when Rochambeau's son, Donatien-Marie-Joseph de Vimeur
Vicomte de Rochambeau, first laid eyes on Betsey Whipple of Cumberland
is little spoken about or remembered. He had come to America as aide-
de-camp to his father when the French fleet landed at Newport with forty-
four vessels and five thousand men on July 11, 1780. Traveling from the
Regiment of Bourbonnais in North Providence, he first saw her when she
was dismounting from her horse at the Friends Quaker Meeting House along
the Great Road in Smithfield, later becoming Lincoln. That dismounting
rock is still there, as is the Friends Meeting House, which is used for worship
services. Later, Rochambeau saw her dancing with General Washington at
a party given by his father at Hacker's Hall, the magnificent social gathering
place. Truly a belle of the ball, Betsey was asked to sit at Washington's side
during this and similar events.

Preserved Whipple Arnold (1828–1919), a cousin of Betsey Whipple, was
proud of his heritage and knew the story of Vicomte Rochambeau spending
time courting her.

Despite his pleas and the gift of his beloved horse, the count could not convince Betsey to marry him and live in France. *Illustration by Gordon Rowley.*

Betsey, who lived in Cumberland, loved to visit the old, stone chimney house known as the splendid mansion of Eleazer Arnold on what is today Great Road in Lincoln. Her uncle welcomed his beautiful young niece, who attracted suitors far and wide. She turned them all down, and for the most part they left downcast but not bitter—all, that is, except one young man who took Betsey to various local functions and also wanted to marry her. One evening, coming home from a gathering, they crossed a dark field leading to her house in Cumberland. One more time, the man asked for her hand and one more time she said no. Clearly upset, the suitor abruptly turned and walked away, leaving her to stumble through the darkness to her house. He had also taken the lantern that lighted their way. Betsey told that story to her family for many years but refused to name the jilted suitor. One story that she could not hide, however, was that of the most romantic time of her long life—her courtship with the dashing young Rochambeau.

Imagine the sight of this young gallant and decorated soldier in his Bourbonnais uniform riding up to that house on his magnificent black charger, Le Duc. The young count couldn't keep away from Betsey, nor she from him, and a romance soon blossomed as bright as the lilies of the valley they planted in her uncle's garden.

In 1782, the war was all but over and the French troops were returning from the British surrender at Yorktown. It meant they would soon sail for France, and that included the young count. Rushing to Betsey, he asked her to come with him where they would be married. Reluctantly, she declined after word had reached her that the count was supposed to marry another woman as part of an arrangement that would join two highly respected families in France. Her Quaker nature would not allow herself to become part of a breakup, regardless of how the count felt about it. Sadly, they parted, and the French troops left Providence on June 18, on the way to Boston and then across the Atlantic. There had been a great parade on that day, as recorded by historians of that time: "The sparkling Regiments of Bourbonnais, on the nineteenth the Royal Deux-Ponts, on the twentieth, the Regiment of Saintongue left successfully the camps of Providence, keeping always between each other the distance of a day's march. Crowds were present to witness their departure." Betsey didn't go to see the event, and she and the count never saw each other again.

Two days after the troops moved out, a messenger came to the Arnold house, where Betsey was staying, with a gift. It was Le Duc, the black charger that the count had ridden throughout the war. Attached to his mane was a note:

*My chere, I didst say thee art a little virgin. Thou art. But I shall die unless I leave thee some remembrance of a friendship that smells as sweet in memory as the vale-lillies in thy garden. I know that any gift from my hand would be spurned as thou has spurned my love. Therefore, I shall send thee by a messenger whom thou shalt not see, a token of the great regard I bear thee.*

*Thou canst not return Le Duc for his master is far away. I am leaving him in thy care while life lasts…Be kind to him for the sake of one who does thy bidding. Adieu forever.*

The note was signed Donatien-Marie Joseph de Vimeur Rochambeau.

Betsey cared for the animal for the rest of its life, even spoon-feeding it porridge from a silver spoon when it could no longer stand.

Young Rochambeau continued in the military, once spending nine years in a British prison. He was killed in the Battle of Nations in October 1813 at the age of fifty-nine.

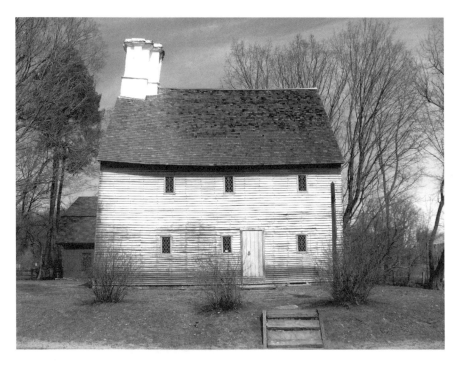

The Eleazer Arnold House in Lincoln, Rhode Island, where Betsey and the count courted. They both cultivated flowers in the yard. *Author's collection.*

Betsey lived for sixty-five years after the Revolutionary War, dying at the age of ninety-six on July 30, 1847. She had never left Smithfield, which became the town of Lincoln in 1871, nor Cumberland, where her will is still on file at the town hall. She was buried with her parents and sister beneath a shady tree at Swan Point Cemetery in Providence overlooking the Seekonk River.

In her will, which she dictated in 1832 and was recorded at Cumberland Town Hall on September 6, 1847, shortly after her death, Betsey mentioned several family members to whom she gave small amounts of money. She also wrote about Sally Collar, "who was brought up by me" and given "the sum of $25 to be paid her by my said executrix within one year of my decease."

In 1976, the Lincoln Bicentennial Commission selected the romance of the count and Betsey Whipple as the theme for its float, with a replica of the Eleazer Arnold house and the two young lovers watched over by Mr. and Mrs. Arnold. It was entered into four major parades that summer and won first prize in all of them.

On July 30, 1976, the anniversary of Betsey's death, a memoriam was placed in the *Pawtucket Times*: "Preserved in the sight of the Lord is the death of His servants. Thou may'st love on, evermore through love's eternity." This is from her monument at Swan Point Cemetery.

# DASTARDLY DEED IN SOUTH KINGSTOWN

Captain Thomas Carter tried to ride out the storm, but his coasting vessel was too small and it ran aground of the Connecticut coastline in that freezing December 1750. He was on his way to New York from his home port of Newport when the craft broke up and sank along with its cargo. For Carter, all was lost.

Without money or transportation, Carter began walking back to Newport wet, tired and sick that his goods were gone. Along the way, not far from the Rhode Island border, he met William Jackson, a well-to-do merchant from Virginia who was traveling with two horses, one of which he was riding and the other loaded with deerskins, on his way to Boston to make some serious money selling them. Jackson took pity on the ragged-looking Carter, and the two of them made their way on horseback into South Kingstown, across the Narragansett Bay from Carter's destination.

On New Year's Day 1751, the pair stopped at Willard's Tavern on the Old Post Road and, according to long-ago writings, "partook of rest and refreshments." The manager of Willard's was a widow named Nash who fed them and even sewed a button on Jackson's jacket. She noticed that the black-haired Jackson had a streak of white on his head and volunteered to dress his hair. Carter and Jackson left the tavern later that evening, refusing to stay overnight, opting instead to make the Franklin Ferry that crossed into Newport. Mrs. Nash made what would ultimately be the most controversial and telling statement of her life when she told Jackson, "If anyone should murder you I can identify your body by that queer lock of hair."

The Ye Olde Tavern was owned by Willard Hazard, and a few years after Carter and Jackson stopped there, Colonel George Washington and several of his aides also stayed there on February 27, 1756.

As midnight approached, Jackson and Carter passed in front of what are now the Stedman Government Center and an animal hospital on Tower Hill Road. Carter had seen a bag of silver that Jackson carried, some of which he used to pay their tolls and stay at Willard's Tavern. Coming up behind Jackson, he slammed a large rock onto his head, stunning him, but Jackson managed to ride to an abandoned house and attempt to hide inside. It was to no avail, and Carter stabbed him twice in the left breast and once in the neck. Jackson fell and lay mortally wounded while Carter dragged him down a hill and pushed him under the icy water at Pettaquanscutt Cove. He then made his way to Newport with Jackson's horse and goods, which he soon attempted to sell.

Several days later, a man spearing eels at the cove discovered the remains of a man under the ice and notified the King's County sheriff, Rowland Robinson, who ordered the body pulled to shore. One of the

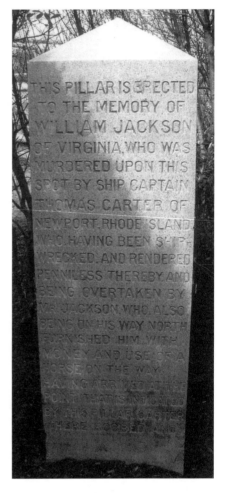

The monument erected at the site of the murder of a good Samaritan: "This pillar is erected to the memory of William Jackson of Virginia, who was murdered upon this spot by ship captain Thomas Carter of Newport, Rhode Island."

many people who came to see the gruesome sight was the widow Nash, who noticed the lock of white hair. She also ran her hand down the front of the body's vest and discovered the button she had sewn on Jackson's coat.

Armed with a description of the suspect, Sheriff Robinson took the ferry across the bay and rode into Newport looking for Carter, whom he found at a sister's house, sitting by a fire with his niece on his lap. Carter apparently

surrendered without a struggle and was brought back to South Kingstown on the back of the sheriff's great steed.

We digress for a moment to look into the character of Rowland Robinson and his firstborn child, Hannah. Robinson's home is still standing on Old Boston Neck Road. It is where Hannah was born to Rowland and his wife Austis in 1746 and where she was raised without wanting for anything. She spent many hours by a large rock near her home gazing at Narragansett Bay. Although a loving child, she had inherited a stubborn streak from her father that would cut her life short at the age of twenty-seven.

Rowland Robinson sent his daughter to Madame Osborn's finishing school in Newport, where she would benefit from the best education a young woman could ever wish for. It was at Madame Osborn's that she fell in love with one of her teachers, Peter Simon, who taught French and dancing. They carried on a secret romance, knowing that Rowland Robinson would never allow his daughter to marry a poor teacher, but eventually he found out and forbade Hannah from going near Peter. Thanks to Hannah's uncle and a woman friend named Miss Belden, the pair was able to hatch a plan to elope.

Hannah had an aunt named Ludovick Updike who was holding a ball at Smith's Castle, eight miles north of the Robinson house. Today, Smith's Castle is a popular tourist attraction with a rich history of its own. Robinson let Hannah go to the ball with her sister Mary and a servant named Prince, who, legend has it, was actually an African prince. Hannah and her party of unwitting conspirators made their way north toward Cocumscussoc, Indian land named by Roger Williams, where they met Peter, who took Hannah and rode to Providence, where they were secretly married.

Rowland was furious and cut Hannah off from any funds or other help except supplying her with a maid. He offered a reward to anyone who would reveal who had helped Hannah elope, but even Hannah herself would never tell. Peter had married Hannah for her money, and when he realized that there would be nothing, he abandoned her, breaking her heart and ruining her health. Eventually, Rowland Robinson came around and, visiting her in Providence, sobbed at her condition and what he had been responsible for. He brought her home, and she asked her father to stop at a ledge where she had often sat as a child and where she could look at the beautiful landscaping above the bay. Flowers grew next to a large rock, and she picked one of the blossoms before returning to her girlhood home, where she died on October 30, 1773.

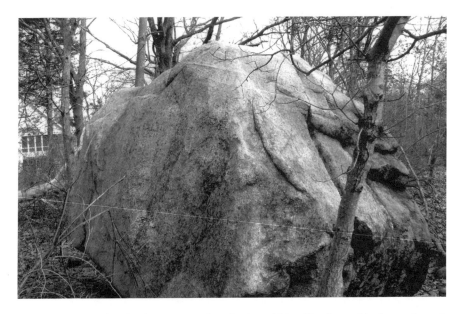

The large memorial rock where a young heartbroken girl is said to have visited near the end of her short, tragic life. *Author's collection.*

Hannah was a small child when her father brought in Thomas Carter. He initially pleaded not guilty but eventually confessed, was tried and convicted. He was condemned to hang, but while awaiting execution, he complained that his handcuffs were too tight. The jailer brought in a blacksmith named Mr. Hull to relieve the pressure, only to have Carter smash him over the head in a vain attempt to escape. Carter expressed disappointment that he had failed in his quest for freedom.

On May 10, 1751, a large crowd gathered in the eastern section of Tower Hill to watch Carter meet his maker. A chill must have gone through those in attendance when it was announced that after the hanging Carter's body would remain on view in chains until it rotted away.

The Reverend James MacSparron, preaching at the site, gave Carter the last words he would ever hear: "Oh, Lord, look down upon this unhappy, poor man who needs Thy pity and Thy pardon. Oh, let not him whom we are now commending to Thy mercy forever perish and be lost."

Carter's body was suspended in an iron frame at the site of his hanging for a long time. When the wind blew, the chains would rattle, and at night neighborhood children would lie quaking in their beds at the eerie sound. For the rest of their lives, people would relate the story of Captain Thomas

Carter and the creaking chains. Today, the story is told on a four-foot monument that can be seen in the bushes at the town's animal shelter.

The jailer, Thomas Hazard, also had a beef with Carter. While Carter was being held at the South Kingstown jail, Hazard was ordered not to leave it or to receive any visitors because of the threat of Carter's associates possibly trying to break him out. Following Carter's execution, Hazard petitioned the Rhode Island General Assembly for five pounds a week due to lost business. He had suffered what he called in his petition a great loss. The assembly agreed and paid Hazard.

# TRAGEDIES *and* CALAMITIES

# A TALE OF TWO BETS
# AND A GIANT

It may not seem possible, but until the late 1700s, Rhode Islanders had never seen an elephant. In fact, no one living in the United States had. Mastodons and the woolly mammoths had died out ten thousand years before, so when a pachyderm arrived on the ship *America*, commanded by Jacob Crowninshield at New York Harbor on April 13, 1796, it became a major event. Crowninshield, who bought the elephant from Bengal, India, for $450, was a Salem, Massachusetts businessman who became a congressman and was named secretary of the navy under President Thomas Jefferson, although he died before he assumed those duties. He exhibited the elephant for a short time at Broadway and Beaver Street in New York City and then sold it for $10,000, an enormous sum at the time. This first elephant, known only as the Crowninshield, seemed to have disappeared from public record soon after being sold. A second elephant was imported into Boston Harbor in 1804 by Edward Savage. A year later, a Somers, New York farmer named Hackaliah Bailey bought the elephant, which he named Old Bet, originally for farm work, but due to the crowds she attracted, he began showing her publicly. Using some of the large amount of proceeds derived from showing Old Bet, Bailey built a hotel named, appropriately enough, the Elephant Hotel in Somers. Atop a pole next to the hotel, he placed a wooden figure of an elephant. James Anthony Bailey, an adopted son of Frederick Bailey, a cousin of Hackaliah's, teamed up with P.T. Barnum seventy years later and formed the Barnum and Bailey Circus. Elephants remained a featured attraction, and in 1881, Bailey bought the most famous elephant, Jumbo, for

his circus. As we shall see, Old Bet; a successor, Little Bet or Betty, as folks in Chepachet, Rhode Island, called her; and finally Jumbo all met violent and early deaths, two of them in New England.

## OLD BET AND LITTLE BET

"The greatest curiosity ever presented to the public." That is how a Boston newspaper described the Crowninshield elephant in July 1797. By the time Hackaliah Bailey bought the elephant about 1805, she had made a fortune for her handlers, and it became clear to Bailey that Old Bet should not spend her days on a farm. He began showing her up and down the East Coast during the warm weather and keeping her in a large barn during the winter at his home in Somers, New York. The years were good to Bailey, and he reaped financial rewards far beyond anything he had made raising and selling cattle on his working farm. In 1816, he took Old Bet to Alfred, Maine.

The sharpest criticism leveled at Bailey had been from the religious community, who complained that shows staged on Sundays were harming church attendance. Instead of attending services, people would flock to see Old Bet. When Bailey and Old Bet were crossing the farm property of a religious fanatic on a Sunday in 1816, the farmer shot Old Bet in the eye, killing her instantly. His explanation was that poor people shouldn't throw their money away on viewing elephants, especially on the Sabbath. There is no record of this farmer ever being punished, although he was brought to trial and acquitted. Years later, a plaque was placed at the site of the killing along Route 4 in Alfred.

While Bailey was devastated by the murder of his main source of income, he did not waste time in getting another elephant to show. This time it was Little Bet, better known as Betty, from Calcutta, India. She was called the Learned Elephant. Local historians like Edna Kent relate stories about Betty that have become legend as to why she was called the Learned Elephant. Betty was able to uncork a bottle, take a drink and then cork the bottle again, all with her trunk. Bailey brought her from town to town up and down the East Coast, thrilling crowds who had not seen Big Bet and even those who had. In 1822, Betty was shown in Chepachet, Rhode Island, to much fanfare. Betty was twelve years old and weighed six thousand pounds, thus adding to the onlookers' awe. Visitors paid twelve and a half cents to see her in the tent in which she was kept. From the Carolinas to the rock-bound

The spot on the Chepachet Bridge where Betty was shot and killed has become a tourist attraction. *Author's collection.*

coast of Maine, Betty walked on display to curious villagers, making serious money for Bailey.

However, he was responsible for the demise of Betty because of his big mouth. Bailey boasted that the elephant's hide could not be penetrated, and making this kind of claim sealed the fate of his prize. The easiest way to have something damaged, stolen or destroyed is to let the public know about it, and that is what happened to Betty. There is more than one theory that has been passed on through the decades as to Betty's demise, but the facts surrounding it were hushed up for so long that we only have those theories. One involves a feud between a mill owner and Bailey over money. The tale is told of how the mill owner offered financial freedom to some men who were in debt to him if they killed the elephant. One of those men owned a Mathewson rifle developed by a New England gunsmith named Welcome Mathewson early in the nineteenth century. Its power and accuracy were second to none. In the early morning hours of May 25, 1826, as Betty wrapped up the Chepachet leg of her latest tour, she was being led across a bridge in the village when a shot rang out, striking her in the eye and killing her instantly. It was the same

type of assassination that had taken down Old Bet. The investigation revealed that the shot was fired from the second-floor window of a gristmill, and seven men were eventually arrested and fined. Some of them were Masons and were expelled from their lodge. Fines totaled $1,500, but the shame brought upon them was worse than the financial punishment, and although it was kept as quiet as possible from other parts of the state, those in Chepachet never forgot who they were or what they did.

Following the shooting of Betty, her carcass was dragged down a side street across from the bridge and skinned. The hide was sent to a Boston museum and the bones were reported to have been saved, although none of them was ever displayed. For 150 years, folks in Chepachet tried to forget, but on May 25, 1976, on the 150th anniversary of the tragedy, a plaque was placed on the bridge where the original bridge stood and marked the spot where Betty breathed her last. It is still there today.

# JUMBO

Finally, the most famous elephant of all, and certainly one of the largest ever to be brought to this country—his name was Jumbo, and even today something that is very large is referred to by that name.

Jumbo was born in the French Sudan in 1861 and raised in the London Zoo, where kids would be hoisted onto his back for exciting rides. He did not have a name when he was purchased from France, so the London Zookeepers called him Jumbo because of his size.

In 1882, Jumbo was sold to P.T. Barnum, who operated his self-proclaimed "Greatest Show on Earth" for Barnum and Bailey Circus. It was a heartbreaking time for the kids of London, who bombarded Queen Victoria with 100,000 letters begging her to stop the sale of Jumbo.

Jumbo grew to eleven and a half feet tall at the shoulder and became the showcase of the circus. The $10,000 Barnum paid to buy him and another $20,000 to transport him by ship to America was a great investment, for people flocked to see the giant animal and brought in $1.5 million in the first year.

Jumbo was twenty-four years old by September 15, 1885. As the circus animals were loaded onto rail cars following a performance in St. Thomas, Ontario, tragedy struck. Jumbo and a baby clown elephant named Tom Thumb were making their way across some tracks to their Palace Car when an unscheduled freight train began bearing down on them. There are several versions of what happened next, the most logical is that Jumbo

*After a disagreement with his partner, who owned half of Old Bet, Hakaliah Bailey threatened to shoot his half.*

"Elephant Rifle." This cartoon appeared in P.T. Barnum's 1855 autobiography, but Bailey claimed that he was only kidding when he threatened to shoot his half of the elephant. *Courtesy of Terry Ariano, Somers, New York.*

pushed the baby out of the way and was struck head-on by the train. Jumbo died of a smashed skull, and the train was derailed. Jumbo's death made headlines around the world. His hide was removed and mounted at Tufts University outside Boston, where Barnum had established a small museum. His bones were put together and taken to the American Museum of Natural History in New York City, where they remain on view today. Sadly, a fire tore through the building where Jumbo's hide was displayed, destroying it. The engineer on the train that struck Jumbo met his own end during the 1906 San Francisco earthquake.

So ends the story of three large and fascinating animals, all connected in one way or another to Hackaliah Bailey, the farmer from New York who had little luck with elephants. In the name of money, these elephants were taken from their natural habitat and forced into show business with the result being that they never lived the long lives of their friends and relatives who stayed behind, beyond the clutches of their captors.

# LIFE BECAME TOO MUCH

On Friday, November 6, 1818, thirty-three-year-old Hopestill Jenks of Cumberland put her four young children into the family's horse-drawn carriage (then called a chaise) and drove to her father's house in Smithfield, quite a distance from the Jenks home on Mendon Road, now site of Davenport's Restaurant, a popular dining spot for Rhode Islanders. Her father, Joseph Mathewson, had recently been widowed and lived alone. Apparently, Hopestill had been suffering from depression since her youngest child had been born a year before and needed to be with her father. The visit may not have gone well, according to people who knew her and would talk about what happened next for many years.

Instead of going home after her time with Joseph, Hopestill drove the wagon to Scott's Pond, so named by Richard Scott, who was the first proprietor of the land surrounding that body of water. It was sunset, and strapped in the wagon were Hopestill's four children: Betsey, age eleven; Rhoda, age five; Harriett, age two; and Louisa, age one. A five-year-old son named Liberty had died in 1815, and friends theorize that that incident added to Hopestill's depression. She was about to cause a tragedy that people would discuss and wonder about for a long time.

On the south side of Scott's Pond, there was a section that had washed away from the bank and dropped off so steeply that it had created a sudden and dangerous area. In the middle of the eighteenth century, a Newport man named Lopez was returning from a visit in Worcester with his family and servants when he fell into the pond and drowned. He had been riding in

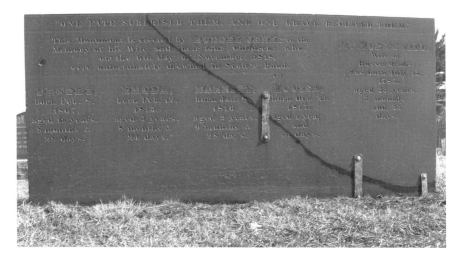

The grave of Hopestill Jenks and her children in Cumberland, Rhode Island. Their funeral brought out thousands of people. *Author's collection.*

Scott's Pond in Lincoln, Rhode Island, where Hopestill drove her wagon with her children tied on it. *Author's collection.*

a sulky, and as he was driving the horse to the pond to drink, the animal lost its footing and tumbled in. Twenty years later, a fifteen-year-old boy named Asa Arnold drowned while trying to swim across the pond.

These were sad incidents, but nothing compared to what happened on that cold afternoon in November 1818 when Hopestill Jenks, in front of several patrons of a tavern next to the pond, drove the wagon into the water off the bank. Colonel Dexter Aldrich was in that tavern and yelled to her. Some of the women there brought rope to the edge of the pond where the children were struggling, and two men ran to Hopestill's aid but did not jump into the water because they claimed they could not swim.

Finally, a man brave enough dove into the water and grabbed the horse's bridle to lead it out. Two of the children were still in the wagon secured by rope but could not be revived. Hopestill and one other child were located later that night, and the last child was found the following morning.

Hopestill's distraught husband, Russel, a farmer, had his entire family laid out in the living room of their home. During the services, eyewitnesses counted 510 carriages and 4,000 people who came to view the remains. The Reverend Mr. Carrique read from Psalms: "I know O Lord that thy judgments are right, and that tho in faithfulness has afflicted me. Let, I pray thee, they merciful kindness be for my comfort according to thy word unto they servant."

Today, their graves may be seen in the Rhode Island Historical Cemetery number nine, also known as the Ballou Cemetery, on Old Mendon Road in Cumberland. It is in front of five-year-old Liberty Jenks's stone, and when Russel died at age fifty-nine on May 8, 1842, he was buried there along with his second wife Julia, who lived until 1868. It appears that Russel married immediately after Hopestill's death. Russel's tragic life continued after marrying Julia: their son George died at age six in 1824.

There are several variations on the spelling of Jenks. In fact, when Russel died his name was spelled Jenckes. Another family member buried nearby has the name Jenkes carved into it.

# THERE USED TO BE A TERRACE

Next to Wampanoag Indian chief Metacomet, or King Philip, as he was called by southern New Englanders, Chief Pomham, Sachem of Shawomet, was the most feared during the wars of 1675–76. He was killed in a raid at Natick, Massachusetts, during the summer fighting in 1676, and King Philip was shot to death and then chopped up soon after, his head displayed in Plymouth for the next twenty-five years.

According to historians, Pomham was not only feared but he was also much maligned, but because Native Americans rarely kept written records during the Indian wars, little is known from their point of view. What is known is that Pomham's village was at Warwick Neck, where his people hunted and fished until hostilities virtually wiped them out.

Today, when the name is mentioned at all, it is usually in connection with Pomham Rocks and the Pomham Light House, both still evident along the shores of Narragansett Bay off the Veteran's Parkway. People who grew up at Pomham Terrace say that it is a forgotten community, and this talk finally made its way to George Murdock.

George T. Murdock Jr. wrote about Pomham Terrace and compiled a loose-leaf binder of photos and notes. George liked to do such things and spent considerable time putting together a book about the history of the East Providence Fire Department. He had served in the army during World War II and kept active at the American Legion Post #10. When he died in September 2005 at the age of eighty, his daughter Karen gave me his book, complete with names of people who lived at Pomham Terrace and photographs of the folks who were now fondly recalling their youth there.

# Pomham Terrace
## Riverside, RI

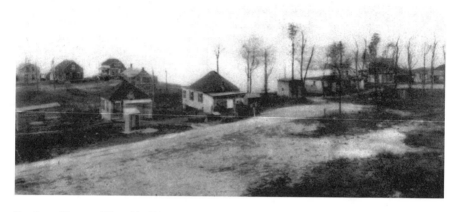

Pomham Terrace, Riverside, Rhode Island, which was virtually wiped out in the 1938 hurricane. *George Murdock Collection.*

Pomham Terrace as a community did not last long. It was created around the beginning of the twentieth century in the Riverside section of East Providence and took its name from the Pomham Rocks, named after the Indian chief Pomham. Today a lighthouse, built in 1871, sits on rocks near the shore. George spent his summers at Pomham Terrace in a house that his grandparents, Robert and Lillian Lees, built in the early 1900s. George wrote, "As we passed over the Pomham Bridge, with the bright sunny sky as a background, the lighthouse came into view and the smell of salt air filtered into the car."

George enjoyed every minute of those summers until he was thirteen, in 1938. There were fifteen houses on the Terrace and everyone knew everyone else. On September 21, that all changed as a monstrous hurricane came roaring up Narragansett Bay, sweeping away all but three of those homes.

As the winds began to rip apart Pomham Terrace, people scurried about trying to save what they could. One resident had a boat near the Pomham Rocks, and as he tried to bring it in, he began to lose control and be swept out into the roaring waters of the bay. The lighthouse keeper spotted him, jumped into his own boat and saved him. His wife did not know if he had drowned, so she kept ringing the lighthouse bell throughout the night and finally found out the following day when the hurricane had moved on that he was indeed alive. It was a story not told until this book.

Thelma Work and her five siblings grew up on Pomham Terrace. She remembered the day the hurricane hit and telling her mother to look out her window just in time to see some of the neighborhood houses being blown out to sea. "They just lifted up and went out to sea."

Ed Menzel, a young fisherman from East Providence, tells the story of his father calling some men he was going fishing with at Pomham and canceling the trip, saying that he had a bad feeling about the weather. Later that afternoon, when the winds began to pick up, Ed and his father went down to Sabin's Point to secure his brother's boat. After tying the boat to some pilings, they left, only to return during the hurricane's full force to watch the houses along the waterfront being swept away and breaking up.

Beverly Gregory Viau also grew up on the Terrace.

*It was so well known that the mail would be addressed with your last name and just Pomham Terrace. There was no need for a street number. It started out as a summer resort and soon became home all year-round to a lot of the residents. Times were tough in those days, and we were all like family. I can remember all of the neighbors getting together for a potato bake on Ruth Island, which is located just before the Pomham lighthouse. No one had hot dogs or hamburgers but it didn't seem to matter. We made the most of what we had and always had fun there.*

Beverly says she was the neighborhood go-fer. "I used to go to Morris Store to get everyone's bread. I could just about see over the top of the bread on the way back."

Some of the best memories of those who lived there, according to Beverly, concerned swimming.

*We had the best swimming pool in all of Riverside and started in April. We had Narragansett Bay and the Pomham Lighthouse in our backyard. I can remember my baby sister Shirley swimming to Ruth's Island at low tide and then an old fisherman used to bring her back to shore hanging on to the back of the fishing boat. Thelma [Work, Beverly's older sister] and my brothers were strong swimmers. (They had a good teacher, my mother.) One day Don [brother] and Thelma, along with some friends, decided to swim across Narragansett Bay from Pomham to Gaspee Point in Warwick. It was over a mile each way. Each swimmer had a boat next to them.*

None of them made it all the way, and their mother was onshore urging them to come back.

Mabel Gregory, the Angel of Pomham, with Beverly, Donald and little Shirley sitting on the family car. *George Murdock Collection.*

"In spite of hard times, we were very lucky to have a place like this to grow up. I will always cherish the memories of my brothers and sisters and of Pomham in my heart forever," Beverly concluded.

## THE ANGEL OF POMHAM

Standard Oil had a ninety-nine-year lease on the land at Pomham and eventually wanted those whose homes had not been wiped out by the hurricane to move so it could take over all of the property and develop it as a sewage treatment plant. One woman refused until she was paid: Mabel Gregory, Beverly and Shirley's mother. Standard Oil finally paid her $500 in 1950, and that was the end of homes on Pomham Terrace.

"She [Mabel] was the real angel of Pomham," Beverly said. "Boys would get into fights and she would make them shake hands. Everyone in the neighborhood would go to her for her opinion. If Standard Oil hadn't come in, we would still be there. I would sit and talk to my mother for hours. And she'd never lie. She used to say, 'If you want to lie you'd better have a good memory.' She was quite a woman."

# TRAGEDIES ON THE RAILS

There have been many fatalities involving people and trains in Rhode Island since the 1850s. Three are worth telling because of the number of lives lost and the question of who or what was to blame for these horrendous accidents. The causes of these train wrecks can be attributed to a conductor's watch being slow in Valley Falls, a noisy party of revelers in Cumberland and a washout of the rails in Richmond.

## THE VALLEY FALLS COLLISION

Fred Putnam was a thirty-dollar-a-month brakeman for the Providence and Worcester Railroad who had been working as a conductor for two weeks leading up to the morning of August 12, 1853. The railroad company did not provide such things as watches, so conductors had to buy their own. Fred, on his brakeman's salary, could not afford a good watch, so he borrowed one from a milkman friend and used it to bring in his trains. The milkman's watch was always two minutes slow, and thus Fred's trains were never exactly on time.

The Uxbridge down train, with seven cars and 475 passengers bound for Narragansett, left Uxbridge at 6:30 a.m. and was supposed to be at the Boston switch near Valley Falls, a section of Cumberland, at 7:29, where it would pass the two-car up train from Providence. The railroad rule was for that up train to wait five minutes if the down train was late. After that, the

Boston switch would be thrown and the up train would have the right of rail. If the Uxbridge train could not reach the switch by 7:34 a.m., it was supposed to stop at some point above the switch until the Providence train came up.

The night before the fateful trip, Putnam set his watch by the railroad company's time at Providence and the following morning pulled into Valley Falls at 7:30 a.m., according to his watch. It was actually 7:34. Putnam knew that he was late but figured he had enough time to make it past the switch. At 7:37 a.m., the switch was thrown, putting the up and down trains on a collision course. They smashed head-on into each other, instantly killing thirteen people. A survivor had his arm severed and a five-year-old boy lost his arm as well. The engineer of the Providence up train was scalded and the brakeman for the down train suffered broken ribs. Putnam, after working the brakes as well as he could, jumped to safety.

According to a story by Robert L. Wheeler that appeared in the "Rhode Islander" section of the *Providence Journal*, the conductor of the up train, Perry Cord, ran up to Putnam through the smoke and debris and asked, "Putnam, what does this mean?"

Putnam said, "I am running on my own time. I have a watch that is right." When they compared watches, Putnam's was ninety seconds behind Cord's.

A coroner's jury found Putnam responsible for carelessness, inexperience and needing a better watch. His bosses were blamed for putting him in charge as a conductor and not giving him a better timepiece. They were also charged with not paying him a decent wage. Then Putnam was fired and charged with manslaughter, all because he borrowed a milkman's watch.

A photograph of the train wreck was taken by L. Wright of Pawtucket. It was a daguerreotype, said to be the first picture ever taken of a train wreck. An artist for the *New York Illustrated News* on August 27, 1853, sketched the photograph, and both images gained wide distribution.

## DEATH ON THE RAILS IN RICHMOND

On the morning of April 19, 1873, a dam used by the G.N. Ennis Grist Mill to supply a reservoir for its operation burst, washing out a small bridge that spanned the Pawcatuck River in the Rhode Island town of Richmond at what today is known as Wood River Junction. The dam had held back some forty

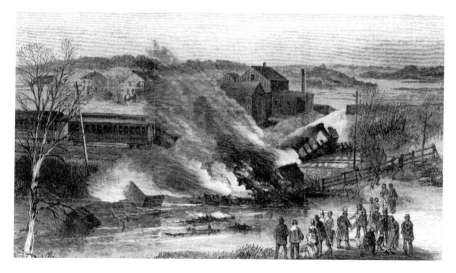

The Richmond train wreck was reproduced in several newspapers and magazines because of the bizarre events surrounding it. *Courtesy of* Providence Sunday Magazine.

acres of water, and over that bridge trains from the Boston and Providence Railroad ran daily and nightly. The breaking of the dam destroyed the thirty-nine-year-old bridge and subsequently the tracks, leaving a hole where a train would go. Heavy rain had swelled the water at the mill and caused the washout.

At 3:00 a.m., the Steam Boat Train heading for Providence and then Boston out of Stonington, Connecticut, hit the scene at forty miles an hour. It consisted of an engine, two first-class passenger cars, one second-class passenger car, a smoking car and three flat freight cars.

The engine became airborne, imbedding itself seven feet headfirst into the mud forty feet across, with the rest of the cars forming an accordion behind it. There had been 116 passengers and crew members packed into those cars. Most of the passengers were immigrants whose meager belongings were piled into the freight section of the train. Suddenly, the engine burst into flames, the fire shooting through all the cars despite the water surrounding the wreck. The stunned and sleeping passengers were trapped. Some of the 116 people onboard were killed instantly, such as engineer William D. Guile, whose body was discovered between the driving wheel and engine; Firemen George Eldridge and Albert F. Allen, owner of Allen's Fire Department Supplies on Eddy Street in Providence; and Jerry Creamer of Boston. Guile's hands were still on the lever that he had put in reverse in an attempt

to stop his train. Others were burned beyond recognition. The only way the engineers were identified was by their position in the engine. A burned body of a woman was found floating in the water the next day. The body was identified as female because of the corset it was still wearing.

The horror stories at the scene continued and were reported in newspapers throughout New England.

*"Guile's Signal"*

*Two low whistles, quaint and clear,*
*That was the signal the engineer*
*That was the signal that Guile, 'tis said*
*Gave to his wife at Providence*
*As through the sleeping town and thence,*
    *Out in the Night*
    *On to the Light*
*Down past the farms, lying white he sped*
*As a husband's greeting, scant no doubt*
*Yet to the woman looking out,*
*Watching and waiting, no serenade,*
*Love song or midnight roundelay,*
*Said what that whistle seemed to say*
    *To my trust true,*
    *So, love, to you,*
*Working or waiting, Good night! it said.*
*Brisk young bagman men, tourists fine*
*Old commuters along the line*
*Brakemen and porters glanced ahead*
*Smiled at the signal sharp and intense*
*Pierced through the shadows of Providence*
    *Nothing amiss*
    *Nothing-it is*
*Only Guile calling his wife they said.*

*Summer and winter the old refrain,*
*Rang o'er the billows of ripening grain*
*Pierced through the budding boughs o'erhead*
*Flew down the track where the red leaves burned*
*Like living coals from the engine spurned*

*Sang as it flew:*
*"To our trust true"*
*First of all duty, "Good night" it said*

*And then one night, it was heard no more,*
*From Stonington over Rhode Island shore*
*And the folk in Providence smiled and said*
*as they turned in their beds, "The engineer*
*has forgotten his midnight cheer"*
*One only knew*
*To his trust true*
*Guile lay under his engine dead.*

Guile's ashes were brought to Swan Point Cemetery in Providence after a Masonic funeral at St. John's Lodge and buried under a white flat stone in the rear of the cemetery. Today, it can barely be seen, but one can just make out the writing on the stone: "Peace to his ashes, honored by his name, what nobler death has mortal ever died. While courage is revered the name and form of Guile will be remembered with true pride."

The story does not end there. Cries of blame were leveled at the Providence and Boston Railroad Company. The *New York Times* charged the railroad with a "wholesale massacre." The newspaper also wrote, "This public spirited railway company was not content with drowning and burning its passengers. It added to the horrors that of telescoping of two of its cars and the subsequent crushing of many of its occupants."

The official investigation began on April 23, and by May the final report was issued exonerating the railroad and its operators and recommending passage of a law requiring all railroad cars to carry fire extinguishers, axes and pails.

## WINTER TRAGEDY IN LONSDALE

Long before television and radio, folks would socialize at night and during the weekends. In the cold winter months, one of the most popular forms of entertainment was the sleigh ride. Up to thirty people could bundle up in a large horse-drawn sleigh carriage. Being driven to dinner and shows proved to be a wonderful way to spend time with friends and family.

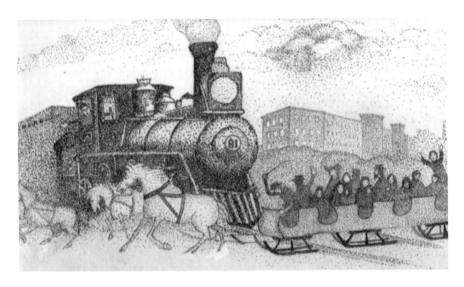

There were no photographs taken of the Lonsdale disaster, even though the carnage was evident for days. *Illustration by Gordon Rowley.*

That changed forever in the early morning hours of January 18, 1893, when twenty-four people in a sleighing party crossed the train tracks on Mill Street in the Lonsdale section of Cumberland. On one side of the tracks was the depot. On the other, the one closest to the sleigh was Ann and Hope Mill number three, a large building that blocked the view of any train that might be coming. At 12:40 a.m., four horses drawing a large and elegant sleigh stepped onto the tracks at the New Village Crossing next to the Ann and Hope Mill. They had left Webb's Oval at Dexter and Barton Streets and were coming from a night of dining and entertainment at the International Hotel in North Attleboro, Massachusetts, having convinced the driver to take the Lonsdale route home. They were singing "One Last River to Cross" and laughing, making more noise than the Frog Freight 1101 train's whistle being blown by engineer Harry Atwood. Seeing what his eyes could scarcely believe, Atwood threw the engine into reverse, to no avail, as the heavy train continued on the slippery tracks for one hundred yards. It slammed into the sleigh, flipping it over several times and sending bodies of people and horses flying into the chilly night.

Seven people were killed instantly, as were the two lead horses. The train's crew rushed to the aid of those still alive, and a call went out to doctors in the area to hurry to the grisly scene. One of those doctors was Lucius Garvin, soon to become governor of Rhode Island and currently the state's medical

examiner. He was quickly joined by other doctors as they worked feverishly to save lives. People living in surrounding houses were awakened by the cries of the victims, and soon a crowd had gathered at the site. Dr. Garvin ordered the dead removed to the depot next to the tracks where the accident had happened. Reporters covering the accident described body parts strewn about the blood-covered snow that blanketed the ground. Those critically injured, especially two young women, Annie Sullivan and Fannie Flynn, were lifted into the caboose of the train and taken to Providence, where they were removed by wagon and rushed to Rhode Island Hospital. Before being taken away, Miss Sullivan was visited by Reverend Father P.J. Malone of nearby St. Patrick's Church. The expression on the dying woman's face went from contorted agony to peaceful as the young priest bent over her and whispered a prayer of comfort. She died overnight at the hospital.

Meanwhile, work continued on the floor of the waiting room at the depot, where survivors had been brought as doctors worked on the most seriously injured. Outside, curious neighbors stared at the sleigh, which was largely intact. The train had struck the front of it, killing the lead two horses while the other two instinctively made their way home to the barn of C.E. Thurber on Cross Street in Pawtucket, who owned the five-seat yellow sleigh. Sadly, the horses had broken their hooves and had to be destroyed. Two forward seats were crushed and woodwork along its side was smashed upon impact. It was still a grim scene when the sleigh was taken away by two new horses sent by Thurber. Blood and bits of flesh and torn clothing were strewn over it. Inside the depot, where reporters were allowed, one described the scene as "sickening." Seven bodies had been laid out on stretchers and covered with white sheets. In a separate box were large bones and flesh from the victims. Outside, men were clearing the blood from the depot platform and rails using brushes and hot water where a large crowd had gathered. The tragedy grew when the parents of William Draper came to view his mangled body. Draper had been dragged under the train. His mother caressed her oldest son's face, her sobs echoing throughout the cold morning air.

Most of the dead were brought to a funeral home on Park Place in Pawtucket, where a steady stream of family, friends and curious poured through the building. A young woman identified Mary Hamilton and said that the dead woman had been like a mother to her and her brothers and sisters since their own mother had died four months before. Then William Draper's mother came again for the first time since viewing her son's broken remains at the Lonsdale depot. This time, the undertaker had done his best to make her son presentable, yet her anguish had not lessened. After the

bodies had been prepared, they were taken to their respective homes for a final viewing before burial.

Amid the emotion and heartbreak, an investigation was begun by the superintendent of the Providence and Worcester Railroad, F.G. Spenser. Although it was determined that all signals were working, there was no watchman at the site after 9:00 p.m. Engineer Atwood said there had been thirteen cars attached to his engine and the first thing he saw was the horses. In examining the cowcatcher, he found parts of the horses' harness and a blanket stuck to it.

By the end of the weekend, most of the victims had been laid to rest. On Sunday, Daniel S. Richardson was buried, leaving a grieving pregnant wife and four children, the oldest age nine. Richardson was the driver of the sleigh, and his wife remained seriously ill in a state of shock.

Charles Edgar Thurber, owner of the sleigh, was a successful Pawtucket businessman who owned twenty horses and fifteen wagons, including sleighs that he rented out for excursions when the snow was on the ground.

The investigation revealed that no one on the train was at fault, but the tragedy never faded from the memory of those who lived through it and passed the story on to future generations. A memorial card was printed in memory of those killed on that terrible early morning:

> In memoriam of: Daniel S. Richardson, Mrs. James Draper, Mary A. Fawcett, Mary Ann Hamilton, Annie Wilson, Robert Cook, William H. Draper and Annie Sullivan who were killed at a grade crossing in Lonsdale, Rhode Island on the morning of January 18, 1893. We were eight now we are none, Not one left, no not one, Our lives were short and our death was fast, All joys and sorrows now are past, Our weary souls now rest in peace, We obeyed our savior's call, Eight we were, but now are none, And dwelling all in all.

Today the train tracks are still there, and so is the depot, although it is dilapidated.

# TRAGEDIES AT SEA

## THE SINKING OF THE *LEXINGTON*

During the era when steamboats were seen traveling Narragansett Bay, one of the finest was the *Lexington*, built in 1835 by the Bishop and Simonson Shipyards in New York City. Commissioned by Cornelius Vanderbilt, the 207-foot, 488-ton side-wheeler served as a day boat, making trips between New York City and Providence, Rhode Island, and then to Stonington, Connecticut. The *Lexington* also became the fastest vessel between New York City and Boston, making it very passenger friendly. Five years after its christening, the *Lexington* would lay at the bottom of Long Island Sound with a loss of almost 140 lives.

On January 13, 1840, temperatures had fallen to near zero and high winds whipped across Long Island Sound. There were also high seas, and the strongest boat was required to make the journey. The *Lexington*'s motto was "Through by Dawn." The usual captain was Jake Vanderbilt, but he was sick that night, and the job of bringing the *Lexington* to Stonington on time fell to George Child, a veteran of many years in that capacity. At 4:00 p.m., he steered the paddle out of the pier at Manhattan's East River. There were 143 passengers and crew along with 150 bales of cotton stacked near the ship's boiler. The ship was due to arrive at Stonington the following morning, with passengers then boarding a train for Boston.

The pilot of the *Lexington* was Stephen Manchester of Connecticut. Several people onboard were Rhode Islanders, including the clerk, Jesse Comstock

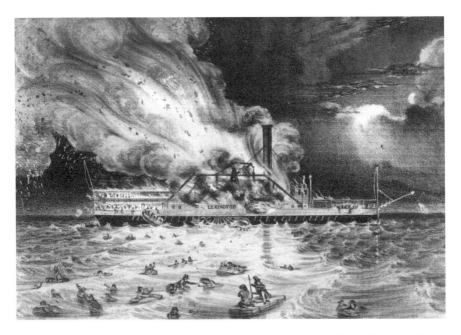

The *Lexington* went down in flames with one hundred people onboard in 1840. Many of them were Rhode Islanders. *Courtesy of the Mariners Museum, Newport News, Virginia.*

Jr., and Second Mate David Crowley, both of Providence. Comstock's brother, Joseph, was also a ship's captain aboard a packet ship between Providence and New York. Another relative, Samuel Comstock, had been murdered after he and some shipmates staged a mutiny aboard the whale ship *Globe* in 1824.

It was 7:00 p.m. when the passengers finished dinner and began relaxing aboard the *Lexington*. Suddenly, the first mate noticed that the woodwork and casings above the smokestack, where much of the cotton bales were piled high, had caught fire. Crew members, in order not to start a panic among passengers, grabbed buckets of water and a small hand-pumped fire engine and began dousing the flames. The ship was only four miles from Eaton's Neck off the north shore of Long Island, and pilot Manchester tried to steer the ship toward it. Two miles from land, the rope that controlled the rudder burned through, rendering the ship helpless. Unable to reach the boilers to turn them off, the ship's rudder continued to spin out of control, causing the ship to flounder. By now, the passengers knew that the ship was ablaze, and the three lifeboats were ready to launch. When the first boat filled with passengers was lowered, it was sucked into the paddlewheel and everyone

was crushed to death, including Captain Child, who had fallen into it. Ropes used to lower the other two boats failed and they crashed headfirst into the water, drowning the occupants. The bales of cotton that may have caused the fire to start were now ablaze, and some of those bales were tossed overboard and acted like rafts. At 8:00 p.m., the main deck collapsed, killing more passengers. The rest simply jumped overboard, and most froze to death or drowned. By midnight, everyone was off the burning ship, and when it went down at 3:00 a.m., it was still on fire.

Of the 143 people who had boarded the *Lexington*, 4 were now alive, and only one of them was a passenger. Twenty-four-year-old Captain Chestier Halliard, traveling as a passenger on his way to Norwich, Connecticut, had helped the crew throw bales of cotton overboard, jumping on the last one at 8:00 p.m. The ship's fireman, Benjamin Cox, also clung to the bale, but suffering from hypothermia, he fell off and drowned. At 11:00 a.m. the following day, Halliard was rescued by the sloop *Merchant*. For the rest of his life, Halliard would remember seeing a dead child floating in the water and its mother on the burning steamer begging to save her child before she went down with the ship.

Also surviving was the pilot, Manchester, among the last to abandon ship. Another bale of cotton had acted as a raft, and he was rescued at noon the next day by the *Merchant*. Charles Smith, another of the firemen, managed to hang on to a piece of the paddlewheel with four others. He, the lone survivor of that effort, was picked up by the *Merchant* at 2:00 p.m.

The most extraordinary tale of survival belongs to Providence resident David Crowley. Crowley, the second mate, drifted on a bale of cotton for forty-three hours, making shore about fifty miles to the east at Baiting Hollow, Long Island. Miraculously, when he staggered ashore, he walked another mile to the home of Mattias and Mary Hutchinson. When he arrived, they brought him to River Head, where he recovered. The Providence man lived a long life and kept that bale of cotton for many years. Finally, as the last living survivor of the fire, he donated it to the Civil War effort. Never again was cotton stored near a boiler, and immediately sufficient lifeboats were required on all vessels. Ironically, when the *Titanic* sank in 1912, one of the reasons so many passengers died was that there were not enough lifeboats.

An inquest was held to determine the cause of the tragedy, and it was found that the ship's boilers, which had been designed to burn wood, had been converted to the much hotter-burning coal the year before but had not been completed. A spark from the white-hot smokestack ignited a wooden casing, which quickly set the cotton ablaze.

The crew was also blamed at the inquest. The jury said, "Had the buckets been manned at the commencement of the fire, it would have been immediately extinguished." The jury also wrote, "The conduct of the officers deserves the severest censure of this community. From the facts proved before this jury that the captain and pilot in the greatest hour of danger, left the steamboat to her own guidance, and sought their own safety, regardless of the fate of the passengers."

Attempts have been made to raise the *Lexington*, but to no avail. In 1842, the wreck was briefly raised and silver coins were removed, but chains holding it broke and the *Lexington* crashed to the bottom in 140 feet of water, breaking into three pieces.

## CURSED AT SEA

On a small plot of land in the North Burial Ground in Providence, one will find several stones memorializing the Comstock family. A closer look will reveal that many of them lost their lives at sea.

Jesse Comstock Jr. died aboard the *Lexington*, and his brother, Captain Joseph Comstock, was named by the Transportation Company to head up the search for bodies. Jesse was never found, but there is a stone in his memory.

Another brother, William Weeden Comstock of Providence, lost his life when the USS *Artic* went down off the coast of Newfoundland after striking a French ship, the *Vesta*, on September 27, 1854. Of the 408 people onboard, only 87 survived. The ship was considered one of the most luxurious in the world. It left New York City and was heading for Liverpool, England, when it went down. Reports from local newspapers of the day told of the crew pushing women and children out of the way and jumping into lifeboats. Another Providence man, William Rathbone, managed to survive, but the ship's first assistant engineer, George Drown of Providence, died when the *Artic* sank. The *Vesta*, an iron-hulled ship, stayed afloat.

On November 3, 1850, Benjamin Weeden Comstock, another brother, died aboard the steamship *Empire City* on the way from Chagres, Panama, to New York.

Charles O. Fenner, related to Rhode Island governor James Fenner, married William Weeden Comstock's sister. They had a son, also named

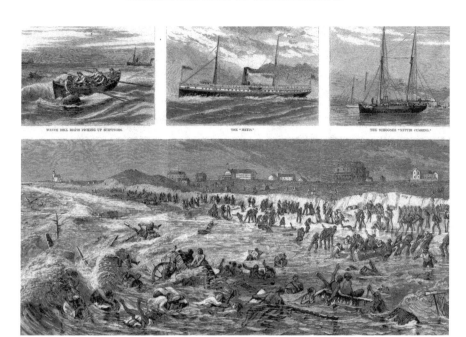

Debris from the wreck of the *Metis* off Westerly, Rhode Island, washed ashore because it was so close to land. Harper's Weekly, *September 21, 1872.*

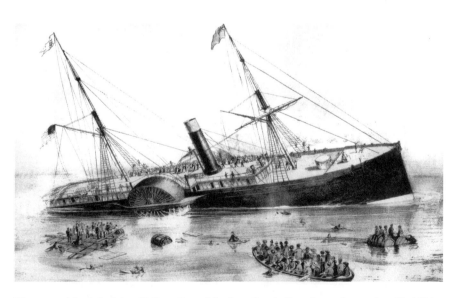

The steamship *Artic* sinks off Cape Race, Newfoundland, Canada, on September 27, 1854. *Courtesy of the Mariners Museum, Newport News, Virginia.*

Charles, who died on the ship *White Swallow* between San Francisco and Hong Kong.

A fourth cousin, Samuel B. Comstock, could be called the black sheep of the family. He led a mutiny aboard the Nantucket whale ship the *Globe* in 1824. Chronicled in the book *Demon of the Waters*, Samuel, born in Rhode Island in 1802, was murdered on the Marshall Islands three weeks after the mutiny. His younger brother, George, also a crew member of the *Globe*, lived to tell of the mutiny and his brother's grisly death.

# RHODE ISLANDERS WHO
# SURVIVED THE *TITANIC*

## HELEN OSTBY

When the ocean liner RMS *Titanic* struck an iceberg south of the Grand Banks, Newfoundland, and sank on April 15, 1912, during its maiden voyage, more than 1,500 people lost their lives. One of them was Engelhart Cornelius Ostby, founder of the Providence-based jewelry manufacturing company Ostby and Barton.

Born on December 18, 1847, in Christiana, Norway, Ostby studied to become a jeweler at the Royal School of Art in Oslo and came to Rhode Island when his parents immigrated. Taking $3,000, he formed a partnership with Nathan Barton and opened a jewelry shop that eventually became the world's largest maker of rings.

In 1876, Ostby married Lizzie Webster, and they had five children, four boys and a girl named Helene. Engelhart Ostby frequently traveled to Europe to compare designs, especially in Paris, and he often took Helene with him. On a pleasure trip in 1912, he heard of the magnificent new White Star luxury liner *Titanic* and quickly booked first-class passage to sail on its maiden voyage to America.

On the night of April 15, following dinner, Ostby and his twenty-two-year-old daughter Helen (who had by now dropped the "e" in her name) sat listening to an orchestra and eventually retired to their staterooms. They were suddenly jolted awake by the crash of the ship into an iceberg, and both made their way to the first-class deck to meet for the last time. Engelhart

Helen Ostby survived the sinking of the *Titanic*, but her father did not. She was raised in great privilege and lived in this Providence home for most of her life. She never married and worked extensively doing church work. *Ostby Family Collection.*

returned to his stateroom to get warmer clothes and Helen climbed into lifeboat number 5. They never saw each other again.

Helen had initially gone back to find her father and thought that he had gotten to the top of the ship by a different route. Later, she was reunited with her family in New York City, where she and the other survivors were taken after being rescued. There, she related what she could of the traumatic event to her brother Raymond:

> *As soon as I got on deck I met Mr. and Mrs. Frank Warren and we remained together for a short time waiting for father. A commotion had begun at that time and the escaping steam made it almost impossible to hear conversation. People all around us were putting on lifebelts so we three did the same. I wondered what kept father below however, and went down to try and find him. I guess my father must have come up on deck some other way for I could not find him in the stateroom. I went back and was waiting for him when the crew came around and told us to get into one of*

*the boats. We all hung back awhile. I wanted father to come with us but the man insisted that we hurry up so I got into the lifeboat with some other women and a man.*

Fifty years later, Helen was better able to remember the painful details of that night. In a 1962 interview with the *Providence Journal*, she recalled the darkness and the sinking of the *Titanic*:

*By the time we were lowered to the water the* Titanic *had begun very noticeably to go down by the head. The stars were out but it was pitch dark. As we pulled away we could see the lights of the ship and the lighted forward portholes gradually disappearing. The first of about eight distress rockets went off so high in the sky that they startled everyone. At the end we could hear people on board and were realizing there was no place to go. As the ship began to stand on end we heard a big rumbling, rattling noise as if everything was being torn from their moorings inside the ship. She stood quietly on her end for a minute and then went down like an arrow. When somebody happened to mention jewelry left behind, I remembered for the first time that I lost a diamond bar which was given to me by my father which was still pinned to my nightgown aboard ship. I hadn't given it a thought and when I was reminded it didn't matter.*

Helen recalled seeing John Jacob Astor IV clinging to a life raft until his hands became so frozen that he simply slid off to his watery grave.

Helen never married, but she led an interesting life. She had been traveling in Europe when World War I broke out and managed to narrowly escape before the Germans arrived in France. She lived for ten years in Belgium and escaped in 1940 just as the Nazis invaded Brussels.

Helen spent much of her time after 1940 volunteering at Rhode Island Hospital and was deeply involved in Grace Episcopal Church in Providence.

Engelhart Cornelius Ostby's body was found by the *Mackay Bennett*, one of four ships that the White Star Line commissioned to recover victims. The sixty-four-year-old's remains were embalmed aboard the *Mackay Bennett* along with other first-class passengers and turned over to David Sutherland, an employee of Ostby and Barton. His body was then returned to Providence and placed in a metal coffin and then a magnificent mahogany coffin for burial at Swan Point Cemetery. Helen and her brother Raymond sued the White Star Line, as did many other families, for wrongful death and loss of property.

Helen Ostby stayed at the family's mansion at 61 Cooke Street in the city until old age caught up with her. She moved to Wayland Manor Apartments nearby and died there of uremia on May 15, 1978. She was eighty-eight years old. She was laid to rest beneath a tall Celtic cross next to her father.

## BERTHA MULVIHILL

When twenty-four-year-old Bertha Mulvihill traveled from Providence, Rhode Island, to her birthplace in Athlone Westmeath, Ireland, for her sister's wedding, she decided to come back earlier than planned because she missed her fiancé, Henry Noon. She had saved her money working as a waitress at the Perry House, a resort hotel in Newport, and before getting married she had decided to make a final trip to Ireland, where she had been raised as one of ten children. Although she was enjoying what would be her last trip to see her siblings and parents, it was time to get back to finish planning for her life as a wife and mother, so she bought a third-class ticket for seven pounds, twelve shillings on a ship at Queenstown and set off to surprise Henry. The date was April 10, 1912, and that ship was RMS *Titanic*. The *Titanic*, built in Belfast, Ireland, flew a British flag and was on its maiden voyage with 2,227 passengers and crew members, and Bertha found herself in a room with bunk beds near the boiler room. She would remember those accommodations and the food as the best she had ever had on a ship.

Survivors of the *Titanic*'s sinking on April 15, 1912, all had a story to tell, and Bertha was no exception. Bertha later told a reporter that when the ship hit an iceberg, she "heard the shrieks of the steerage passengers, saw the armed officers of the ship keep the men back from the lifeboats until the women had been saved and watched as if fascinated the lights of the *Titanic* as the water crept higher and higher and then went out." When the lights on the ship began to glimmer and go out, Bertha recalled two heavy explosions. "The vessel quivered and seemed to settle. Then she leaned over on the other side a little and slowly sank to her grave. I think I heard the band playing."

Bertha nearly went down with the ship. Being a third-class passenger, she had to remain locked in the lower deck until the upper-class passengers were in the lifeboats. She managed to grab her rosary beads, prayer book and jewelry that Henry had given her when he proposed and make her way to the top deck before being pushed back down by a man, probably frantically

Bertha Mulvihill and Henry Noon at their wedding in August 1912. Four months after she survived the sinking of the *Titanic*, she had become such a celebrity that on her wedding day she climbed out a back window of her house to avoid crowds and ripped her veil on a rosebush. *Courtesy of Mark Petteruti, Bertha's grandson.*

trying to save himself. A sailor showed her a way to the last remaining lifeboat, where she was ordered to jump in. She remembered thinking that it was like jumping from a three-story building, according to her grandson, who had heard the story as a child. Bertha suffered some broken ribs but was safe. The images, however, stayed with her forever, images like that of Margaret Rice, who came from Bertha's hometown in Ireland, standing on the top of the ship but never making it to a lifeboat.

Bertha and the other 704 survivors were rescued by the *Carpathia* and taken to New York City. As she and the others waited in the lifeboats,

> *Dawn was just breaking when I saw a light way off in the distance. I spoke to the nearest sailor about it and asked if it possibly could be a vessel coming to us. He said it must be a ship's light but someone spoke up and said it probably was a boat's light. Then two big green lights broke through the mist above it, and we knew it was a ship coming to rescue us. We cheered and cheered. Some cried. I just sat still and offered up a little prayer and the blessed mother that if I survived I would name my first born child Mary which I did.*

When Henry Noon saw Bertha's name on a passengers' survivor list, he was stunned because he had not expected Bertha to be home so soon. He rushed to New York, where they were reunited. Four months later, Bertha and Henry were married at St. Patrick's Church on Smith Street in Providence. They eventually had five children, four of whom lived to adulthood. One of those children was Frances, who married Joseph Petteruti in 1941. One of their children is Mark Petteruti, now living in Pennsylvania, who keeps his grandmother's legacy alive through his collection of more than one hundred books on the *Titanic* sinking and giving talks about her. "She was so afraid of the water that she would never go back to Ireland to visit her family and wouldn't even go swimming," says Mark. "She was a wonderful woman and I have worked very hard to keep the memory of her alive."

Henry had a good job as a master molder at Brown and Sharpe Manufacturing in Providence, and they settled into a house on Chalkstone Avenue, moving to a beautiful house on Wyndham Avenue in 1928. Henry cast the plate on the World War I monument in Providence. Henry passed away in 1945. Bertha died on October 15, 1959, and was buried with him at St. Francis Cemetery in Pawtucket, Rhode Island.

*Above, left*: Marshall Brines Drew was eight years sold when the ship went down, and he talked about it for the rest of his life. *Courtesy of the* Westerly Sun.

*Above, right*: The grave of Amy Tanner can barely be seen in a Rhode Island cemetery. *Author's collection*.

## MARGARET BECHSTEIN HAYS

Margaret Bechstein Hays was born in New York City on December 6, 1887, and thanks to French lessons, she would become a true heroine for two little French boys kidnapped by their father and survivors of the worst civilian maritime disaster in history.

Margaret lived with her wealthy parents at 304 West 83rd Street in New York City. She had gone to Paris with a friend from Briarcliff School, Olive Earnshaw, and Olive's mother, Lily Potter, and was returning from Cherbourg on the RMS *Titanic*. Margaret and Olive, who was in the middle of a divorce, were sharing cabin C-54 in the ship's first-class section when the accident occurred. When the engines suddenly stopped, Margaret and Olive went to Lily's room, where she instructed them to find out what had happened. A few minutes later, they returned with news that the ship had struck an iceberg but that everything was okay and they should go back to bed. Lily was frightened, and all three dressed. Accompanied by Margaret's dog, a Pomeranian that she had bought in Paris, they went topside, where they were helped into life jackets by a man named Gilbert Tucker Jr., a thirty-one-year-old Cornell University graduate who had been pursuing Margaret since they were in Paris. He had been in Europe with his parents but decided to return early to be with Margaret. All four and the dog were allowed into lifeboat 7 and were saved.

When the *Carpathia* picked them up, there were two survivors who posed a mystery. They were two little French boys who spoke no English and were nearly naked. Margaret volunteered to look after the youngsters, who were dubbed "The Orphans of the *Titanic*" due to their being the only ones not claimed by an adult. Speaking in French, Margaret managed to calm the children, and they soon warmed up to her and her little dog. Not being able to find out what their names were, she dubbed them Louis and Lump. Neither boy understood what had happened, and they played contentedly with the dog and some toys provided them by the crew.

When the *Carpathia* docked in New York City, the boys were taken to Margaret's home, where she cared for them under the supervision of the Children's Aid Society. Newspapers published the photographs of the boys throughout the world. A month later, Marcelle Navratil recognized the pictures and proved to authorities that she was their mother. She was brought to New York City on a White Star Line ship, where she collected her boys, three-year-old Marcil and two-year-old Edmond, and sailed back to France aboard the *Oceanic*.

It is worth noting how the boys happened to be alone when the *Titanic* went down. Their father, Michel Navratil, estranged from Marcelle, had taken them from Nice, France, made his way to Southampton and, under the name Hoffman, boarded the *Titanic* in second class, hoping to get to America and eventually send for his wife to start life over. A witness to the sinking reported seeing a man handing his babies to people in one of the lifeboats before he went down with the ship. The children would later recall their father entering the cabin where they were sleeping, dressing them and putting them in collapsible boat D, the last one to be launched from the sinking liner. "I don't remember being afraid," recalled Marcil. "I remember the pleasure, really, of going plop! Into the lifeboat. We ended up next to the daughter of an American banker who managed to save her dog." He was speaking of Margaret Hays.

Marcil lived to be ninety-two, passing away on January 30, 2001. Brother Edmond fought with the French army during World War II and was captured by the Germans. He escaped, but his health was damaged and he died in 1953 at the age of forty-three.

Margaret Hays did not marry Gilbert Tucker but instead was wed to Dr. Charles Daniel Easton, a Newport, Rhode Island physician. He died in 1934, and she passed away from a heart attack while vacationing in Buenos Aires, Argentina, on August 21, 1956. She and her husband are buried in St. Mary's Churchyard in Portsmouth, Rhode Island.

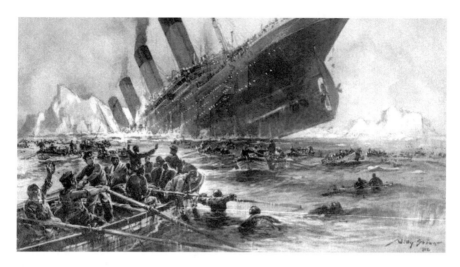

Willy Stower's (1864–1931) famous painting of the *Titanic* going down. Willy was one of the passengers who survived and soon after rendered this image. *Willie Stower Collection.*

Olive Earnshaw got her divorce and married Allen P. Crolius. She spent much of the rest of her life as a volunteer for the American Red Cross. She died of cancer on April 21, 1958, at the age of sixty-nine and was buried at Laurel Hill Cemetery in Philadelphia. Lily, her mother and fellow traveler, lived to be ninety-eight and also volunteered for decades with the American Red Cross. She died on New Year's Day 1954 and is buried with her daughter.

Gilbert Tucker came from a well-to-do family: his father was Gilbert Tucker Sr., a noted author. Gilbert Jr. apparently got over Margaret Hays and married Mildred Penrose Stewart in 1922. He died of pneumonia on February 26, 1968, at the age of eighty-seven and was buried in the Little Chapel by the Sea in Pacific Grove, California.

# HEROES *at* HOME *and at* WAR

# THE SILENT WORLD
# OF JEANIE LIPPITT

She was born into a wealthy Providence, Rhode Island family, one of eleven children of Henry and Mary Ann Lippitt, on January 6, 1852. Henry had become wealthy working in the family's textile business. The little girl was christened Jeanie and enjoyed a privileged life in a large old house at the corner of George and Prospect Streets. Soon the Lippitts moved to a new and bigger house at the corner of Hope and Angel Streets. One morning in 1856, Jeanie woke up to a world of silence. She had scarlet fever, and it had robbed her of her hearing forever.

It was the latest tragedy to hit the Lippitts. Despite their wealth, they were powerless to prevent scarlet fever from carrying off sons Henry, age eight, George, age three, and Frederick, age two, all between March and April 1856. Now Jeanie had it, and even though she lived, her hearing was gone. Only ten-year-old Charles was left in a family that would eventually see eleven children born and only six live to maturity.

Jeanie would also become the first child in the United States to speak and read lips. How she got there is an extraordinary story of a dedicated mother who vowed that her deaf child would talk, a world-famous inventor and a celebrated educator, all available to a family with the means to make it happen.

Jeanie's mother wasted no time in declaring that her four-year-old daughter would learn to speak and not live in a silent and mute world. Although Jeanie had begun to talk before becoming ill, the memory of those words faded away with her deafness. Mary Ann, known affectionately as "Ma," began

by sitting Jeanie in front of her and having her imitate the movement of her lips. Slowly, she began to enunciate, and Mary Ann would print out sentences and have Jeanie do the same so she was able to read, spell and talk all at once. By the time Jeanie was twelve, her speech was nearly normal and she was able to communicate with friends. But as the size of the household grew, Mary Ann had less time to spend with Jeanie, and she sent her off to school like the other children, with Jeanie attending Mrs. Shaw's school. That facility was for upper-class families only and eventually became the present-day Wheeler School. Mary C. Wheeler was one of Jeanie's teachers and would play an important role in young Jeanie's life, as would the man credited with inventing the telephone.

Jeanie's nephew, Henry Lippitt II, the family historian, remembers his aunt and how she spoke. "Her voice would suddenly speak out at a well-lighted dinner party picking up an articulate but not necessarily spoken sentence from someone across the table and out of a clear blue sky out she would come with a clear and concise reply."

Jeanie recalled in a 1940 *Providence Evening Bulletin* newspaper story shortly before her death,

> *In those days a girl had to know Latin or Greek to get a diploma. My mother believed that I would have no use for either, and should concentrate on subjects that were helpful for the special education I personally needed. Her decision cost me my diploma, but my mother was right. Just as she was when I decided to take up piano lessons. Mother thought I should not attempt it and I gave it up. But I did study French and at one time, when we were staying in Paris, I always did the shopping.*

When Henry Lippitt became governor of Rhode Island in 1875, Jeanie was twenty-three years old and had finished her schooling. The new governor began pushing legislation creating a school strictly for the deaf. He believed that they should take a place with so-called normal students and have the right to the same kind of education. Jeanie went to the general assembly and spoke of her own affliction and remarked that there was really no need to go through life using hand signs to express herself. Her mother's exercises proved to the lawmakers that a school for deaf children was needed. After listening to her, the legislators passed a bill creating the Rhode Island School for the Deaf in 1876.

Everyone seemed pleased that there would be a special school for deaf students, but Mary Ann was not. She sought out a teacher of voice

Jeanie Lippitt was a wealthy and proud woman who never let her hearing loss stand in the way of her accomplishments. *Courtesy of the Lippitt House, Providence, Rhode Island.*

physiology in Boston and arranged for private lessons that would require Jeanie to speak even better than she had sitting with her mother. The teacher was also an inventor: Dr. Alexander Graham Bell. Jeanie remembered, "He always arrived for my lesson with a box under his arm about the size and shape of a carpenter's box. That was the box that housed the first apparatus for reproducing the voice in his new invention, the telephone."

Bell had become acquainted with a Cambridge lawyer named Gardiner Greene Hubbard, the first president of the National Geographic Society, who would help finance his work in developing the telephone. Hubbard had a daughter, Mabel, who was deaf and with her mother they visited the Lippitts to find out how Jeanie had been trained with Bell. Mabel was brought to Bell and became one of his pupils. In 1877, she married Bell shortly after the Bell Telephone Company began operation, thanks in large part to the financial support of Gardiner Hubbard. In addition to Mabel and Jeanie, another of Bell's patients was Helen Keller, who hated being deaf more than being blind.

While she was attending school in Boston, Jeanie also developed hobbies and an interest in theatre in Providence. Governor Lippitt was responsible for the creation of the Opera House, which hosted famous actors of the day, including Edwin Booth, brother of John Wilkes Booth, who assassinated Abraham Lincoln. Booth became a personal friend of Governor Lippitt and visited his home on Hope Street. Jeanie learned Shakespeare by reading the lips of the actors at the theatres that she visited twice a week. She also attended dances in Boston and attended Papanti's Dance School, waltzing with several boys, including Theodore Roosevelt. Jeanie also enjoyed horseback riding with her brothers and sisters. The house was constantly filled with young people and parties that Jeanie attended but could never hear.

"I have always done the things other people do," she told an *Evening Bulletin* reporter in January 1940 on the occasion of her eighty-eighth birthday. "I have had a normal life with normal activities and normal responsibilities. And I am sure that this is possible for any deaf person who has the proper training. You must all believe that the deaf can be taught to speak and to do all the things hearing people do."

In 1889, Mary Ann "Ma" Lippitt died at the age of sixty-six, and two years later, Henry followed at seventy-three. In 1906, reflecting on his own career, Dr. Bell wrote about "Ma" Lippitt: "The world should know how much it is indebted to Mrs. Lippitt. The result of her instruction to her daughter undoubtedly had a great influence on Mabel's [his new wife] education."

Jeanie talked about her mother's refusal to accept that deaf and mute children could only learn by sign language. Jeanie was never isolated from society, nor did her hearing handicap prevent her from marrying. On April 18, 1893, she married her aunt's widower and raised his six small children. His name was William Babcock Weeden, a manufacturer, historian and descendant of one of Rhode Island's oldest families, and from then until the end of her life she was known as Jeanie Lippitt Weeden. Her happiness with him did not last very long because William died in March 1912 at age seventy-eight, although by then the six children had grown and were on their own.

When she was sixty-four years old and a longtime widow, Jeanie and her chauffeur, Roy, took a motor trip from Rhode Island to California, traveling 4,460 miles in twenty-seven days. When she returned in October 1916, she published a forty-one-page pictorial account of the adventure.

Late in her life, Jeanie enjoyed being surrounded by her family at her summer home, Willow Dell, at Matunuck on the southern Rhode Island shore. She eventually moved from her mansion at Cooke and Waterman Streets to Wayland Manor in Providence and then to the Sheraton Hotel. Until failing eyesight forced her to eliminate most of her social activities, she served as the historian for the Colonial Dames of Rhode Island for twenty years. She managed to have a sewing club meet regularly at her home right up to the very end of her long life. She died on September 30, 1940. Services were held at the First Congregational Church on Benefit Street and burial followed at Swan Point Cemetery, where all the Lippitts now rest.

Jeanie left ten grandchildren, several great-grandchildren and twenty-four nephews and nieces. Those who spoke to her at the end said that she still had a voice that was nearly normal.

She told reporter Edie Nichols, "All through those childhood years, I was not permitted to feel sorry for myself. And I have never got around to it yet."

# MIRACLE BOY
# IN THE HALL OF FAME

B aseball purists will tell you that miracles are made and not born of a deity, which simply means that skill combined with determination creates what writers call miracles. These so-called miracles have been witnessed in baseball and most other sports since their beginning. We have seen the Washington Senators, in last place every year, suddenly win the 1924 World Series despite the Big Train, Walter Johnson, losing two games and then winning the seventh in relief. When Bobby Thompson hit a home run off Ralph Branca in a 1951 National League playoff game, it was called the Miracle of Coogan's Bluff. The 1969 Mets, record holders for the most losses in a season in 1962, beat the Baltimore Orioles in five games. The Boston Red Sox dramatic wins over the Yankees and Cardinals in 2004 were eye-popping. The same can be said for them in 2007. There were perennial losers, the Tampa Bay Devil Rays, dropping the Devil from their name and turning the American League East on its collective ear. Then there were the 1914 Boston Braves, the first team to have miracle attached to its name.

On July 19, 1914, the Braves were in last place in the National League, fifteen and a half games behind the New York Giants, piloted by the great John McGraw. The Braves also had a fine manager named George Stallings, who believed that his veterans were up to the task of winning games and giving McGraw a good run. There were sixty-seven games left in the season, and the Braves would go on to win fifty-one of them. Lefty Tyler and Hank Gowdy were having outstanding years. They had Rabbit Maranville and Johnny Evers. Leading that scrappy pack in hitting was a five-foot, seven-

Joe Connolly led the hapless Braves to the World Series by having the highest batting average on the team that year. *Courtesy of Joe Connolly Jr.*

and-a-half-inch, 165-pound outfielder named Joseph Aloysius Connolly from North Smithfield, Rhode Island. The twenty-eight-year-old second-year player batted .306, led his team in on base percentage and ended up in the Baseball Hall of Fame in Cooperstown, New York, when a team photograph of the Miracle Braves was presented for a display that can still be seen by visitors. He did not win three hundred games or hit five hundred home runs, but he was a major part of the 1914 team, and despite playing only four years in the big leagues, rightly took his place in that hallowed institution. His name is right there with Ruth, Cobb and Mathewson.

Joe Connolly was born on Friday, February 12, 1886, to Thomas Francis and Mary Ellen Powers Connolly in the house in North Smithfield that would remain the family homestead well into the twentieth century. He was baptized at St. James Church in the Manville section of Lincoln, Rhode Island, and grew up working on his father's farm. One of several children, Joe's older brother Mike was a natural athlete and an exceptional baseball player when he died suddenly, ending what could have been a promising career. It was Joe who began playing semiprofessional baseball in 1908 in leagues that were so prevalent throughout the East. That was also the year that Rhode Island conducted its own world series by pitting local teams against one another. While he was playing for the Providence team, Joe's hitting was noticed by Major League umpire John Rudderham, who had been hired for the event. Rudderham tipped off the manager of the Zanesville, Ohio team, which was part of the Central Association, and Joe found himself pitching for that team. Joe, or Joey, as his teammates called him, hit .309 for Zanesville, and when he had a better year in 1910, his pitching days were over. He had been an outstanding pitcher for Zanesville, once throwing twenty-one scoreless innings, but he also suffered from a sore arm. In 1911, when he was signed by Terra Haute and led the Central League in hitting with a .355 average, a scout for the Chicago Cubs saw him and placed him under contract at Montreal. He was not brought up to the Cubs that year because they already had several hard-hitting outfielders.

Clark Griffith, then manager of the Washington Senators, did need outfielders, however, and took Connolly south for the 1913 spring training season. On April 10, his contract was purchased by the Boston Braves. Joe Connolly was in the Major Leagues at the age of twenty-nine.

It was the era of the dead ball, which simply meant that there were few people swinging for the fences prior to 1920—when Babe Ruth began hitting home runs and changed the face of a game that had also been tarnished by some members of the Chicago White Sox throwing the 1919 World Series.

Baseball had been a speed game, known today as small ball. Batters swung differently, beating out singles, stealing second base and scoring on another single. Between 1900 and 1920, the league leader in home runs usually had fewer than ten. It was also a time when a .400 batting average was not as rare as today. Then along came Ruth, who swung up with powerful arms and shoulders with the intention of hitting every pitch out of the park. A baseball was used for up to one hundred throws by a pitcher, and if it went into the stands, fans were required to throw it back. By the late innings, the ball would often be as dirty as a sandlot ball and tough to see. The spitball was also legal before 1920, until Yankees pitcher Carl Mays threw one at Indians Ray Chapman and hit him in the head, killing him. Ruth, the Black Sox, the spitball and repeated use of the same ball all led to sweeping changes in the game of baseball and ended the dead ball era.

Joe Connolly batted left and threw right and was installed in left field, often sitting down when a lefty was on the mound. Joe, known for his smiling good nature, never complained to the manager, Stallings, whose motto was "Do what you want but don't end up in jail and come to play every day." He was a tough manager who had only played in seven Major League games but who was also bringing the Yankees to a second-place finish in 1910 when he was fired and replaced by his first baseman, Hal Chase, for the final fourteen games. Stallings was a wealthy plantation owner and a profane and some said sadistic manager. Asked to describe his miracle Braves, Stallings said, "We had one .300 hitter [Connolly], the worst outfield that ever flirted with sudden death, three pitchers and a good working combination around second base." He also hated it when his pitchers walked a batter, and on his deathbed at the age of sixty-two he supposedly said, "Oh those bases on ball."

Joe had his own targets when batting against pitchers like Grove "Old Pete" Alexander, who threw hard and was not afraid to buzz one by a batter's chin. In 1915, Alexander, then pitching for the Philadelphia Phillies, was on his way to leading the National League with thirty-one wins and 241 strikeouts when Joe thought he had him all figured out. In one game, Connolly ran up in the batter's box before the ball broke and lined a hit to center field. Alexander, who was known for his occasional hangovers, glared at Connolly and said, "Listen kid, if the ball isn't coming at you fast enough just let me know." From then on, Alexander threw his hardest whenever Connolly faced him, and Connolly felt that he always hit better when facing "Old Pete." Alexander went on to win 373 games for the Phillies, Cubs and Cardinals.

Joey Connolly fit right in as a Major Leaguer, hitting .281 for the Braves in 1913. He stole eighteen bases and had eleven triples, tops in the club. On

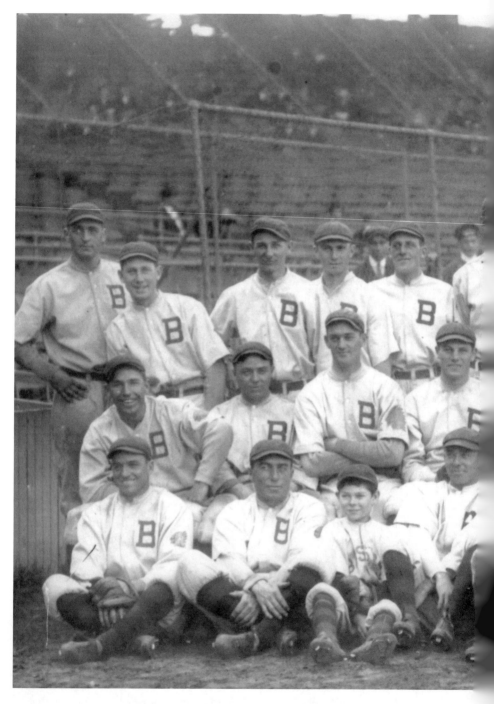

Joe Connolly (front row, far left), with the Boston Braves in 1914, was sent to the Baseball Hall of Fame in Cooperstown, New York. *Courtesy of Joe Connolly Jr.*

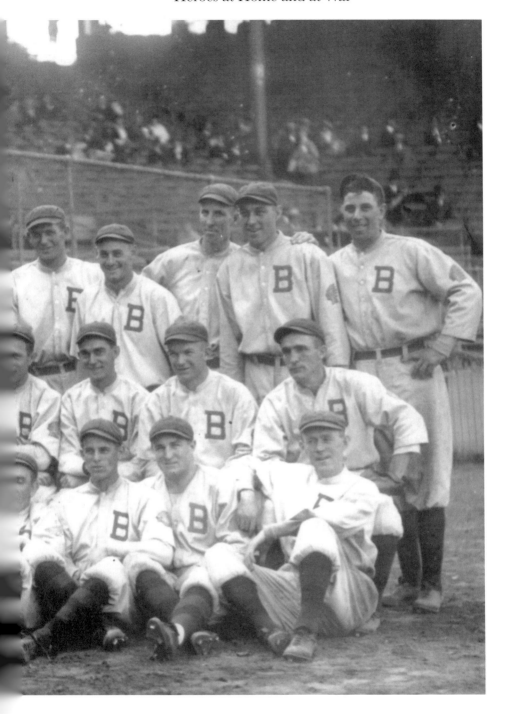

September 21, his season ended when he broke a leg sliding into a base. The following year, he batted .306 with nine home runs, again leading his team in both categories on the way to a four-game sweep of the Philadelphia Athletics. The year 1915 was another good one for Connolly, who batted .298 while missing fifty games. That summer, the Braves held a Joe Connolly Day at Braves Field.

In 1916, his fourth year with the Braves, Connolly showed his independence by walking out on a contract offer less than the $2,400 he had made the year before. His average in only sixty-two games had slipped to .227, and Stallings cut his salary in half. On October 5, 1916, Joe Connolly played his last Major League game. He went home to his family and farm and a civilian life. He married Mary Delaney on October 25, 1916, at St. James Church, helped to raise their kids, worked for nine years as a milk inspector for the State of Rhode Island and made a successful venture into the world of politics. He represented North Smithfield in the Rhode Island House of Representatives in 1933 and 1934 and then moved to the Senate for two more years. He was also the first president of the Sayles Hill Rod and Gun Club and took courses at Bryant College in Providence, studying business.

Connolly lived his whole life in the Sayles Hill section of North Smithfield, and everyone knew him. His son, Joe Jr., was a standout ballplayer and hockey star at Mount St. Charles Academy in Woonsocket. Joe Jr. remembered his father hitting fly balls to him and his friends in a field behind the family farm.

World War II interrupted what might have been a professional career in either baseball or hockey for young Joe when he was drafted in 1943. The date was September 2, the same day a newspaper headline read "Joey Connolly called out by Great Umpire."

On September 1, the elder Connolly was sitting on his living room couch being examined by the family physician, Dr. McCarthy, when his heart suddenly stopped. He was fifty-seven years old. That night, Joe Jr. had a date with his soon-to-be wife, Marguerite, but he hadn't yet left the house. The next morning, when he went to get the mail, his notice to report for duty in the navy was waiting. He did not tell his mother right away and within days was given a three-month reprieve.

American League umpire Bill Summers, who grew up in Woonsocket and knew Connolly, was on a train heading for Yankee Stadium for a game the following day when he read about Joe. Summers got off the train in Providence and came to a wake for Connolly before heading to New York. Summers had been trained as an umpire by famed coach Frank Keaney, who told him, "Just keep track of the balls and strikes, it shouldn't be difficult."

The *Woonsocket Call* reported that Connolly was a "champion among champions."

Joe Connolly never lost his interest in baseball, becoming active in Catholic Youth Organization activities in addition to coaching at Providence College and helping his brother Michael at Mount St. Charles Academy, where his son Joe Jr. played ball. He was a founder of the Vin Carney Sandlot Baseball League, which was in the middle of its playoffs when Connolly died. Games set for the remainder of the week were cancelled in his memory.

# THE ULTIMATE PRICE OF HEROISM

Family, friends and many who remembered gathered at the East Matunuck State Beach pavilion under sunny skies and watched as a plaque was unveiled honoring trooper Daniel O'Brien. Some shed tears for a lost brother, sweetheart and friends on that day in August 1982.

Danny O'Brien was a twenty-five-year-old Rhode Island state trooper who drowned in East Matunuck as he was rescuing people trapped in a raging Atlantic Ocean caused by the howling winds of Hurricane Carol on August 31, 1954. He was struggling to get residents off and away from Potter Pond as it began to crumble. He used his cruiser to push a stalled car to safety and then drove back, lights flashing on his Ford, looking for more potential victims. He was able to get two other people out of the area just as the water off Succotash Road was rising to a fatal level, washing away the bridge like a paper cutout. Suddenly, as the waves roared across the rapidly disappearing structure, they engulfed O'Brien's cruiser, causing it to stall and trapping him inside. He called for help, and then there was silence. Several hours later, when that help finally arrived at the scene, they found O'Brien's hat floating nearby. His body was discovered amid debris off Succotash Road. A few yards away was the body of six-year-old blonde-haired, blue-eyed Karen Ann Trager, one of nineteen people killed by the storm.

Hurricane Carol was not expected. Like a silent killer, it took aim at the nation's smallest state and hit its mark at 11:37 p.m. on August 30, bringing with it winds up to 125 miles an hour, tossing boats around like toys, uprooting

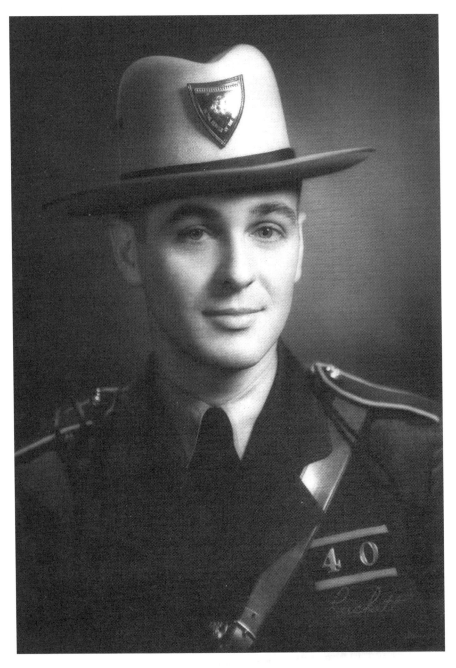

Formal portrait of Trooper Daniel O'Brien, who gave his life rescuing people during Hurricane Carol. *Courtesy of Merry Cassick.*

large trees that had stood for hundreds of years and toppling houses from their foundations.

By late morning, when the newly created National Weather Service finally issued a hurricane warning, it was tragically evident that this was a killer storm. By noon on August 31, it appeared that Carol may have had enough of Rhode Island, but just as winds died down they increased again and continued their destruction. That is when Danny O'Brien went into action.

O'Brien nearly made it to safety. After radioing the Hope Valley barracks that his vehicle was crippled and he was abandoning it, he and a civilian named Alavaro Antone, a thirty-three-year-old resident of Trenton Street in Providence, began making their way arm in arm to higher ground off Succotash Road. Antone later told police that a large wave hit them, breaking that grip and sweeping O'Brien away. Antone said that he saw O'Brien surrounded by debris and trying to remove his heavy raincoat about thirty yards into the waves off the road and knew he was gone. O'Brien was struck in the head by a heavy piece of flotsam and jetsam that was carried along with the water. Trooper Bob McCaffrey found his fellow officer about 6:00 p.m. Another buddy, Howard R. Holt, who had just graduated from the University of Rhode Island, was living with his wife Beverly in Kingston. Howie realized that the storm was a bad one and drove down to the water to see if he could find Danny and give him a hand.

In his biography of the Rhode Island state police trooper, Harold Jones related the story of Lieutenant Ernest A. Eldridge, Danny's commander that day:

> *In 1954 Hurricane Carol, I was District Commander of the Southern District, which received the brunt of the damage and loss of life. I had resigned Danny that morning for a second three year hitch and later detailed him to the Galilee-Jerusalem area of South Kingstown. Later in the morning while I was at Point Judith, I received a message by radio from Danny's car that the ocean was taking his car, and he was abandoning the same. Later in the afternoon we found Danny's body along with a young girl in debris near Post Road.*

Trooper McCaffrey found Danny's body.

> *We heard the announcement* [over the car two-way radio] *that Trooper O'Brien was abandoning 38 car. We thought it was an*

Trooper Danny O'Brien's cruiser underwater off Succotash Road in East Matunuck, Rhode Island, September 1, 1954. *Courtesy of the* Providence Journal.

*accident at first until we got down into South Kingstown and talked with a couple of troopers there and they told us he had left the car; they believed that he was drowning. So we went down to East Matunuck, and we combed the water and at about two O'clock I was told by Lieutenant Leahy to go out and search through the marshland from Trooper O'Brien's car which had the siren sticking out of the water. O'Brien's body was lying face down in the marsh and I knew it was him 'cause he was in full pack, raincoat and boots and rubber boots and everything except for his hat.*

Danny was put into an ambulance and taken to Ford's Funeral Parlor, where Trooper Bill Tocco was assigned to sit with him.

Daniel Lowell O'Brien could have been an Episcopal priest. The oldest of five children, Danny was close to his parish priest, Father Arthur Wood, who had urged him to follow the ministry. Danny was a member and former vestryman of the Church of the Ascension in Cranston but decided to follow his uncle and namesake, Captain Daniel G. O'Brien, who was a Rhode Island state trooper. Today, his nephew Kevin O'Brien is a veteran state trooper as well. Kevin's sister Kelly is married to a state trooper, Bob Mackisey.

Following his graduation from Aldrich High School in Warwick, Danny enlisted in the army, where he spent time in Korea and was proud to do so. He remained close to his church, and when he was discharged he had the occasion to visit Father Wood, who was beginning a Mass but without an acolyte. Danny went straight to the altar while in uniform and took over the duties of the absent acolyte, which impressed Father Wood. On September 1, 1951, he was appointed a Rhode Island state trooper and assigned badge #40.

Danny's sister, Lois Chaney, who is married to an Episcopal priest, thought of her big brother as a hero long before his tragic death. "We thought he was so indestructible because of his confidence," she remembered. "Without question he was that kind of brother, son and friend always putting others first."

Both of Danny's parents were alive when he died and were on hand to receive a posthumous award during a sad ceremony conducted by the state police. Floyd and Bertha had a deep faith that brought them through more tragedies as the years rolled by. Son Robert was killed at the age of thirty when he fell from a firetruck on Jefferson Boulevard responding to a Warwick alarm. He had been struggling to get his heavy coat on when he fell. Brother Allen, living in Pittsburgh and working for Pittsburgh Steel, was about to begin a job in China when a physical discovered that he had cancer. He died at age forty-five. Floyd Jr., known as Junie, died unexpectedly of a heart attack at sixty-four.

"We loved each other dearly," said Lois, the only surviving O'Brien sibling, "and would have done anything to defend each other. Even though the lives, except mine, ended too early, there is much comfort in knowing how much love and respect we had for each other. Some people go through life not even liking each other and that is the real tragedy."

Meredith "Merry" Holt was a nineteen-year-old student at the University of Rhode Island, ready to begin her junior year and engaged to Daniel O'Brien when he died. They were planning a wedding in May 1955, after which Merry would finish her senior year at URI while commuting from the apartment they planned to rent in Lincoln, Rhode Island. Although inconsolable, she carried with her something that her mother said at the time. "She said the worst thing that could happen to you already happened, meaning Danny's death, and that was true until August 2007, when my son-in-law died suddenly at the age of fifty-three, leaving my daughter a widow at forty-nine with two children in college."

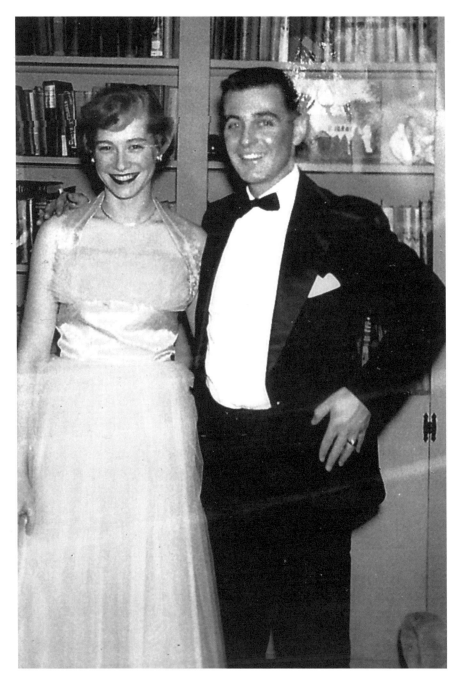

O'Brien and Merry Holt were planning to marry a year later. *Courtesy of Merry Cassick.*

Today, Merry and her husband, David Cassick, are friends with Danny's sister Lois Chaney and her husband Milton. Merry says, "Friendships and love that begin in one's younger years seem to survive whatever life hands them and I am very grateful for that."

# THE FIREMAN'S STATUE

In Pawtucket, Rhode Island, the Fireman's Park is dedicated to all firefighters in the city. But it was originally erected more than one hundred years ago in memory of one who died in the line of duty, Samuel S. Collyer, who was riding on hose carriage number one responding to an alarm of fire from box 75. In July 1884, hose number one was turning the corner of Mineral Spring and Lonsdale Avenue when it slammed into a stone upright post and tipped over.

Chief Engineer Sam Collyer was on the reel in company with Levi Greene (a new member of the department), William J. Daggett, Lewis F. Butler, William Boyd and William F. Worger, the driver. These men were on the step and seat and all were injured. The carriage fell on Collyer, crushing him, breaking his ribs and puncturing his lungs. Several doctors arrived within minutes and carried the injured to their homes.

The *Pawtucket Gazette and Chronicle* gave a lot of space to the accident, reporting:

> The accident has been the general theme of conversation and much sympathy is expressed for the Chief Engineer and his injured companions. We trust that he has a strong will and physical forces that he will triumph and that his life and valued services will be spared these many years to his fellow citizens. Mr. Collyer's condition at 5 o'clock yesterday afternoon was practically unchanged. He is attended by Doctors Morton and Clapp. They report him more comfortable than at any time since the accident.

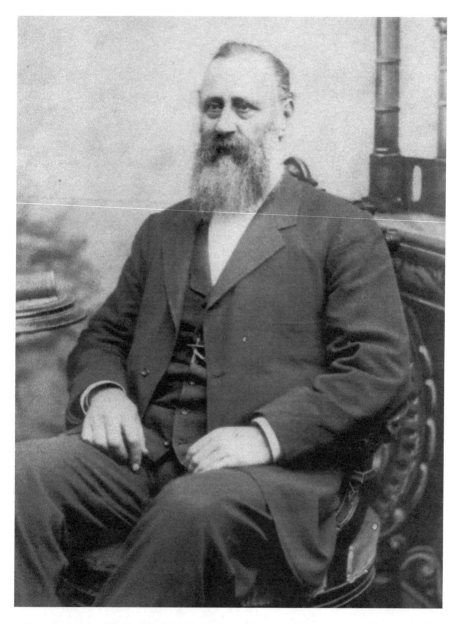

A formal portrait of Samuel Smith Collyer, Pawtucket's first fire chief, who died in a tragic accident on the job. *Pawtucket Fire Department Collection.*

*The chance for recovery, however, is extremely slight. He is kept under the influence of morphine.*

Initially, it appeared that Collyer, although severely injured, would live. He had received internal injuries and a severe scalp wound but managed to rally sufficiently before his removal to ask several questions before lapsing into unconsciousness. That was on Monday night. By Wednesday, however, he remained in a coma and it was thought that he could not last the night. Toward midnight, he again rallied and took slight nourishment and recognized those who were in his room. On Thursday, he remained the same. Levi Greene would recover, as would the others injured in the crash.

Collyer's doctors had also given him opiate for relief from what they said was physical agony. For two weeks, they were optimistic that he would make it until he began to sink quickly. The day before he died, doctors summoned his family and close friends to say that they were losing him. During a period of consciousness, Collyer was able to say that he was not afraid to meet his maker, that the Lord had been good to him and he was ready to obey His summons. Only an hour before he died, he talked to his doctor about how he felt and that he knew the end was near.

On Sunday, July 27, Samuel Collyer lost his fight to live and passed away at 8:53 p.m. His death sent shock waves through a community that had never lost hope that he would survive his horrific injuries. The first fire chief in Pawtucket was gone.

## An Estimate of the Man

*Said a friend to us not many months ago as we stood on Main Street, "What man if suddenly taken from our midst would be the most greatly missed?" "That man," was our reply, as the well known form of Captain Collyer was seen moving from the post office to his place of business. Perhaps the shock of his dreadful accident has something to do with it, but still we feel that the assertion holds good. Never to our recollection has there been such outspoken sorrow by the townspeople, while public and private action by a symbol or resolution to show respect for the deceased has never been equaled.*

—Pawtucket Gazette and Chronicle

Samuel Smith Collyer was born on May 3, 1832, to Isaac and Sybil (Burrill) Collyer and raised on Mill Street in one of the so-called green houses near the Masonic Temple in Pawtucket. He received a common education but had to leave school when he was fourteen because Isaac died and he was needed to support his mother. For a while, he worked at the Pawtucket Post Office under the tutelage of a man named Frederic A. Sumner and then spent several years at the Franklin Foundry and Machine Company, where he worked his way to foreman. By 1860, he was working for his uncle, Nathaniel Collyer, who owned N.S. Collyer and Company on Jenks Avenue. When his uncle died, he managed the company.

But it was as a fireman that he became endeared to the people of Pawtucket. He ran with Old Rough and Ready Number 5 long before he was even old enough to join the company. He had been told by the postmaster that he couldn't be a fireman and a postal worker, so he quit the post office and worked for his uncle. He briefly volunteered in Providence and then took some time off, much to his mother's relief, before joining the Pawtucket Fire Department to stay. In 1874, Pawtucket and North Providence merged their departments and Samuel was elected chief engineer.

Sam's life was the fire department, and he was always on duty. By day, he was ready to respond to any call. By night, he slept with a fire alarm gong in his bedroom directly over his head. His theory was always that a minute or even half a minute gained in getting to the scene of a blaze might save the building.

In 1851, when he was nineteen, Sam married Ellen Whipple. They had a daughter, Mary, and because he had no sons, his name died with him.

A postmortem was held on Sunday afternoon and showed that Sam was terribly mutilated internally and it was a wonder that he had lived at all following the accident. Four ribs were broken on the right side, two of them close to the spine, one of them cutting into the chest cavity.

When the sad news circulated, flags were lowered to half-mast and the engine houses were visibly affected. It was hard to believe that their beloved chief and friend was no more. Immediate preparations began for decorating the buildings in honor of the departed chief. The front of the house of Rhode Island Number One on Fairmount was neatly festooned with black and white with draped national colors over the sign, while in the center was a fine photograph of Chief Collyer in full uniform taken in 1873, when he was chief of the District Department. The frame was entirely covered in black.

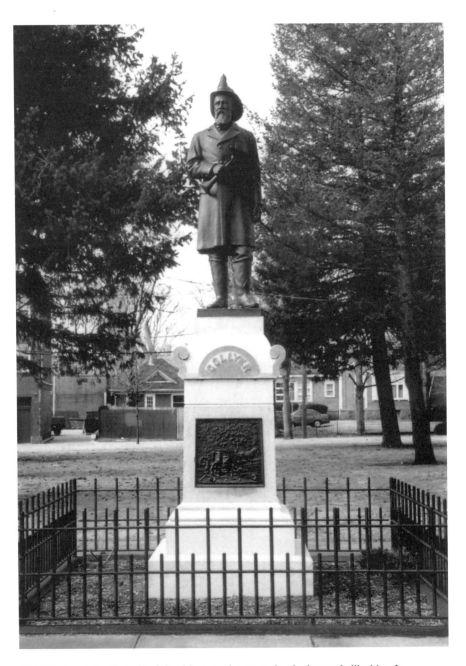

Chief Collyer's family insisted that his statue be created to look exactly like him. It succeeded. *Author's collection.*

The funeral took place Wednesday afternoon at Sam's house, followed by a service at Pawtucket Congregational Church, which was filled with people and flowers, tributes from departments throughout the state. There were floral arrangements of a badge and another in the likeness of the fireman's trumpet. Another was in the shape of a fireman's hat.

Following the service, the procession moved to Mineral Spring Cemetery, across from the park where a memorial would be built. Fire alarm bells mingled with church bells as the people who lined the streets stood in respectful silence. Stores and banks in the town were also shut down until the services and burial were over.

The *Gazette* reported that the town had never before witnessed such a funeral and probably wouldn't again during the current generation. The Pawtucket Fire Department mournfully proclaimed: "Death, in all its terror, in all its mystery, in all its sadness has again entered our ranks and taken from us a gem of brotherhood."

Even years later, the community had not forgotten its fallen hero. In 1890, Pawtucket citizens banded together to raise $2,500. The town commissioned Charles Dowler to sculpt a life-sized bronze statue of Chief Collyer, giving him explicit instructions that the statue's face should be in the likeness of the man and his figure bear his links. Made of Westerly granite, the base of the monument stands eight feet high and four and a half feet wide. It depicts an overturned hose carriage with firefighters lying on the ground and represents the spot at Mineral Spring and Lonsdale Avenues where the accident happened. The town chose a piece of land across from the cemetery and dedicated it to Chief Collyer, naming it Collyer Park, now listed on the National Register of Historic Places.

The morning of October 4, 1890, had been cloudy, but by early afternoon the sun was out and a crowd had gathered for the dedication. There was a parade and music by the famed Reeves American Band and soloist Bowen Church. Governor John W. Davis welcomed everyone, and Colonel Frank M. Bates, a close friend of Collyer's, gave an address, after which General Olney Arnold officially unveiled the monument as a tribute to Samuel S. Collyer. Today, the monument stands at the corner of Mineral Spring Avenue and Main Street.

# THE TRAGEDY
# OF SULLIVAN BALLOU

They dug him up, cut off his head and burned his body to a crisp. Thus ended the heroic days of thirty-two-year-old Major Sullivan Ballou, the Smithfield, Rhode Island–born Huguenot who lost his life during the Battle at Bull Run, Virginia, the first big confrontation of the Civil War.

Sullivan Ballou was born in the Union Village section of Smithfield on March 28, 1827. His father, Hiram, a merchant tailor, died when Sullivan was six years old, and the boy was brought up by his uncle Harry, who along with other family members was able to send him to boarding school in Dudley, Massachusetts, and then to Phillips Academy at Andover. He then attended Brown University in Providence to complete his education. Sullivan was admitted to the Rhode Island Bar in 1853 and elected to the Rhode Island House of Representatives the following year.

Sullivan married the love of his life, Sarah Shumway (1836–1917), on October 15, 1855, and they had two sons, Edgar (1856–1924) and Willie (1859–1948). According to Tom Shannahan, former library director in Central Falls and a Ballou scholar, no photographs of the boys exist.

Fort Sumter in Charlestown Harbor, South Carolina, was attacked by Confederate forces on April 12, 1861, signaling the official start of the Civil War. On June 5, Sullivan was commissioned a major in the Second Rhode Island Regiment. On July 14, Ballou, his commander Colonel John Slocum and the rest of the Second were poised to confront the enemy at Manassas, Virginia. That night Sullivan sat down and wrote his twenty-four-year-old wife Sarah a letter that was so moving and filled with love, yet foreboding,

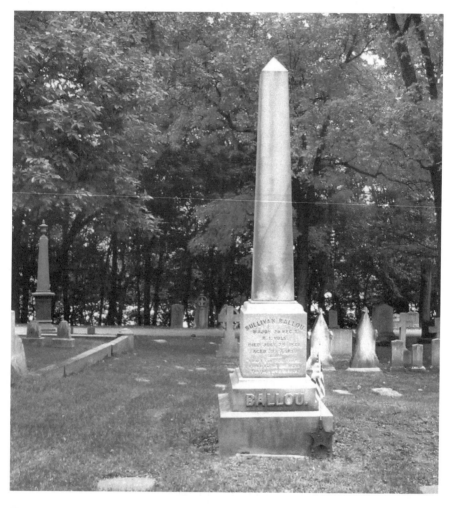

The Ballou grave site at Swan Point Cemetery in Providence, Rhode Island. The love letter to his wife is believed to be buried with her. *Author's collection.*

that it became the basis of a nine-part PBS series called *The Civil War*, produced by Ken Burns. In it, Ballou wrote:

> *My dear Sarah,*
> *The indications are very strong that we shall move in a few days, perhaps tomorrow. Lest I should not be able to write you again, I feel impelled to write a few lines that may fall under your eye when I am no more.*

Ballou wrote of how he was ready to die for his country but also of his love for her and their two sons:

*Sarah, my love for you is deathless. The memories of the blissful moments I have spent with you come creeping over me, and I feel most gratified to God and to you that I have enjoyed them so long. And hard it is for me to give them up and burn to ashes the hopes of future years, when God willing we might still have lived and loved together, and seen our sons grow up to honorable manhood around us. Sarah do not mourn for me dead; think I am gone and wait for thee, for we shall meet again.*

Clearly, Ballou was prepared to die, and die he did next to Colonel Slocum. Both were mortally wounded on July 21, along with twenty-seven of their company.

Slocum was carried to a field hospital at nearby Sudley Church as Ballou, atop his horse Jennie, began directing the remaining men. Suddenly, a six-pound ball fired from the Confederate side tore his leg off and killed his horse. Ballou was also carried to Sudley Church, where he and Slocum hovered near death for several days, finally dying of their wounds. They were buried side by side near the church. Ballou was placed in a coffin and Slocum in a wooden box.

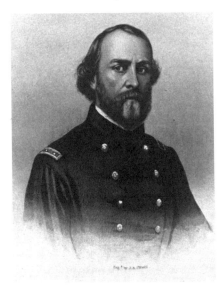

Major Sullivan Ballou was raised in Smithfield, Rhode Island, and was one of the few college graduates in his battalion. *Author's collection.*

In March 1862, the Confederates abandoned Manassas, thus allowing Rhode Island governor William Sprague and seventy troops to embark on a body recovery mission, reaching Bull Run on March 20. Within a day, they were led to the burial site of Slocum by Private Richardson of the First Rhode Island Regiment, who had cared for the wounded officers and helped bury them. When they arrived at the site, they were outraged that Ballou's body had been exhumed, decapitated and burned. A young black girl had witnessed the desecration by the Twenty-first Georgia Infantry, who thought they were mutilating Slocum, a full colonel

and not a major, because of the containers into which the bodies had been placed. With Ballou in the casket and Slocum in a plain box, the men of the Twenty-first had been confused.

The Sprague party gathered the charred remains and a few articles of clothing found in a nearby creek. Other Union soldiers were also exhumed and were found to have been buried facedown in the theory that they would not be able to sit up on Judgment Day. One of those bodies was that of Captain Levi Tower, also of the Second Rhode Island.

The bodies of Slocum, Ballou and Tower were brought first to Washington, D.C., and then to Providence, where thousands of people viewed their flag-draped caskets at the Armory of the First Light Infantry. More than twenty military companies from throughout the state and in full-dress uniforms stood at attention as the bodies were escorted to Grace Church in Providence. Slocum and Ballou were taken to Swan Point Cemetery nearby. Captain Tower was laid to rest beneath an imposing stone at Mineral Spring Cemetery in Pawtucket not far from his home.

Sarah managed to live on twenty-five dollars a month and two dollars for each son allocated by the government. She also made money teaching piano to young boys in Woonsocket. Eventually, she moved to New Jersey to spend her final days with her son Willie, never having remarried. She died there in 1917 at the age of eighty-one. She was laid to rest next to Sullivan, and with her went the original copy of his letter, found in his supply trunk after his death. It had never been mailed.

# GENERAL BARTON:
# A STRANGE OFFICER OF PRINCIPLE

This is the story of a young Rhode Island army officer who became a national hero only to spend his declining years in a Vermont prison over a small unpaid fine in a town named for him.

William Barton planned to become a hat maker in the town of Warren, like his father. The outbreak of hostilities in the Revolutionary War, however, propelled him into battle first as a corporal and finally as a general, placing this brave young soul into planning and successfully carrying out one of the most daring captures of the war, lauded by General George Washington as a turning point for the dwindling morale of colonial troops.

Newport, Rhode Island, had been blockaded by British ships since two English and Hessian brigades occupied Narragansett Bay, quartering their troops in farmhouses with eleven warships to protect them. Their commander was Sir Henry Clinton and one of his top aides was General Richard Prescott. When Clinton returned to England, he left Prescott in charge.

The Rhode Island General Assembly ordered three regiments to be raised to fight the British. One of those regiments was commanded by Colonel Joseph Stanton, whose second in command was Lieutenant Colonel William Barton. They established a small fort called a redoubt overlooking the Seconnett (today spelled Sakonnet) River, which afforded shelter and safety to fleeing residents of Newport. During a lull in the fighting, Barton devised a plan to do away with General Prescott, who had ordered most of the trees in Newport cut down, crops destroyed and people thrown in jail. He was

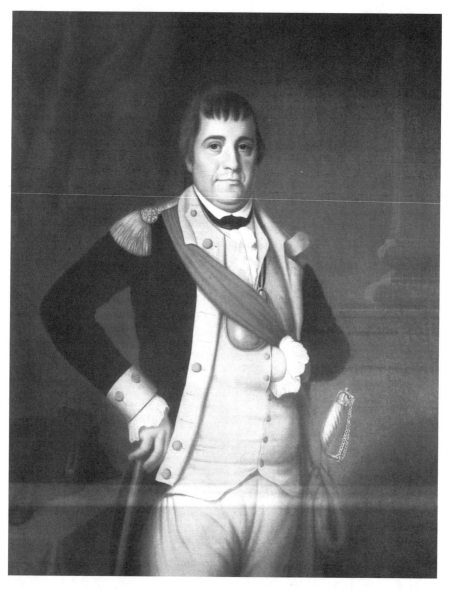

Formal portrait of General Barton hanging in the Rhode Island Historical Society, Providence, Rhode Island. *Courtesy of the Rhode Island Historical Society.*

equally hated by both Newporters and his own men, something that would eventually cause his undoing. Barton was furious that General Charles Lee, the flamboyant top aide to Washington, had been dragged out of a New Jersey saloon by British troops and held captive. Despite his high rank, Lee had failed to have a security detail with him.

In June 1777, a man named Coffin escaped from the jail in Newport and made his way to Tiverton and Barton's headquarters. What he related to Barton convinced him that capturing Prescott could be done.

Coffin, who lived in the area, told Barton that Prescott had commandeered the large home of a successful Quaker businessman, Henry John Overing, several miles north of Newport and forced himself upon the affections of Mrs. Overing. With Prescott was an aide and a sentry but little else except a small band of soldiers three hundred yards away. Barton, meanwhile, was in charge of mostly volunteers and raw recruits. Although they were hardworking and completely dedicated to him, he found it difficult to tell anyone but his own commander, Colonel Stanton, what he planned to do.

Stanton's reply to Barton survives as a handwritten note in the archives at the Rhode Island Historical Society: "Headquarters Camp at Tiverton: Lieu. Col. Barton. You will proceed to the island of Newport and attack the enemy and where you think proper and report to me your findings."

Barton was able to reveal to some of his men that they would be going on a dangerous assignment, but he provided no specifics lest the word get out to Prescott.

He gathered forty men who were experienced at manning whaleboats, took five of those boats, covered the oars with lamb's wool to eliminate rowing noises and prepared to travel to Portsmouth, a few miles up the bay from Newport. It would be a rough journey, taking twenty-six hours to go ten miles in the rain.

On July 4, 1777, one year after the colonies declared their independence from Britain, General Washington watched in dismay as men deserted. More were leaving than were signing up, and morale was at rock bottom. That same July 4 was a warm and intensely dark night. The moon was covered with black clouds that would soon open up, sending a violent rainstorm onto the boats as they made their way slowly through Mount Hope Bay. Finally, all five boats assembled at Hog Island, a small piece of land near the mouth of the harbor and within sight of the mighty British ships guarding it. The rain subsided, and at midnight, with the clouds disappearing, Barton told the men what they were about to do. Years later, Barton recalled what he said on that night as he wrote about his career: "As this may be the last time

I shall have the opportunity of addressing you I offer up my sincere prayer to the great disposer of all events that he will be pleased to smile on our intended enterprise; if consistent with his will may success attend us and each one returned to friends." He then gave his men time to rest for more than a full day before resuming the operation.

On July 9, Barton issued the order not to plunder or take spirituous liquor and above all to remain silent. One of the men, John Hart, who was familiar with the area, advised Barton to put shore on a beach opposite the Overing house, and within minutes all five boats were out of the water. One man was left to guard them and a small detachment was stationed at Warwick Neck nearby. If they heard three musket shots, they were to rush to Barton's aid.

The Overing house was one mile away through heavy brush and a field of rye and blackberry thickets. The house was surrounded by a white picket fence, and all was quiet. Approaching the house, Barton, Hunt and a large black man named Tak Sisson sent to war by a friend of his master's walked boldly up to the sentry who challenged them.

"Who comes here?"

"Friends," answered Barton.

"Advance friends and give the counter sign," the guard ordered.

"We have none but have you seen any deserters?"

Before the sentry, whose name was Graham, could answer, he found his arms pinned to his side with a warning that he was a dead man if he uttered a sound. Graham whispered that General Prescott was in the house sleeping on the second floor. Breaking through the front door, they found Henry Overing in his bed reading. Henry motioned that Prescott was indeed upstairs, and according to stories passed down through generations, Tak Sisson bashed in the door with his head. There they found Prescott sitting on the side of his bed in his nightgown. It is not known if Mrs. Overing was in bed with him.

"Are you General Prescott?" demanded Barton.

"I am," came the reply.

"You are my prisoner."

"I acknowledge it, sir."

Barton ordered Prescott out of bed and refused to let him get dressed, instead dragging him downstairs and toward the waiting whaleboats. Prescott's aide-de-camp, Major William Barrington, tried to escape by jumping from a window without his shoes on but landed into the waiting arms of his captors who had accompanied Barton. Barrington, Graham and Prescott were taken quickly through the brush to the boats. The entire

operation lasted seven minutes. A general commanding four thousand troops encamped on an island surrounded by a squadron of warships had been carried off in the dead of night, half naked, by a party of forty men without a shot being fired.

Within hours, the boats pulled into Warwick Neck and unloaded their famous cargo. Three days later, Prescott was taken by coach to Connecticut and held until he was exchanged for General Charles Lee in April 1778. Near the end of the Revolutionary War, Prescott would be returned to his command in Newport, but he never strayed far from it.

On July 16, 1777, General George Washington wrote to Congress:

> *Sire: I beg leave to congratulate the captivity of Major General Prescott and one of his aides. Lieutenant Colonel Barton and the small handful under his command, who conducted the enterprise, have great merit. I shall immediately propose to general Howe his exchange for that of Major General Lee, which if acceded to will not only do away one ground of controversy between gen' Howe and myself, but will release Lt. Colo Campbell and the Hessian Field officers and procure the enlargement of an equal number of ours in his hands.*

On December 24, Congress promoted Barton to full colonel. He also received an elegant sword and a large cash reward, which he split with the forty men who had helped him capture Prescott.

Hailed far and wide as a genuine hero, Barton's hitch in the army expired and he returned to Providence, settling his family into a large house on South Main Street, where he continued his work as a hat maker.

On May 25, 1778, five hundred British and Hessian troops invaded Bristol, Rhode Island, burning boats, houses and a gristmill before turning on neighboring Warren and setting fire to the Baptist church and rectory, killing cattle and poultry. At eight o'clock the following morning, a dispatch was sent to Barton's home as well as to Brigadier General John Sullivan, who ordered Barton back to duty.

Leading a unit of horsemen, Barton joined forces with troops from Barrington, located next to Warren. Barton spotted a British soldier about to torch the meetinghouse where as a young man Barton had helped plan the town's future, and charged him, sending the startled solider galloping away.

"Come back, you damned coward," shouted Barton. "I am the man who took Prescott and by God, if you just step out of your lurking place, I'll hack you to pieces in less time than it took to take him!"

Prescott's capture, as depicted in this old painting as he is dragged half dressed through the brier patches of Portsmouth, Rhode Island. *Courtesy of the Rhode Island Historical Society.*

Barton raised his sword to further lead his men into battle when a bullet ripped into his thigh, lodging itself in his groin. He was taken to a nearby house, where Dr. Winslow removed the bullet, which was saved for decades by family members.

Barton spent three months in bed and never fought again, although he did gain the admiration of a young general who had sailed from France to join Washington. His name was Marie-Joseph Paul Yves Roch Gilbert du Motier, the Marquis de Lafayette. The young general boasted that the Battle of Rhode Island, in which Barton again distinguished himself, was the best-fought action of the war.

Following the British surrender, Barton traveled to New York, where doctors told him that he would have to have serious surgery to relieve the pain that being shot was still causing him. He explained it in a letter to his wife Rhoda, dated September 6, 1785: "It is the opinion that nothing would do but the extirpation of one of my testicles. Oh horred, m.d. sir, I leave you to judge how horrid I mist feel to go to the Hotest Battels ever fort would not be half do dreadful." Barton did not have the surgery but lived in pain for the rest of his life.

# VERMONT

The state of Vermont and the life of William Barton will forever be linked by a bizarre series of events that led up to the Revolutionary War hero spending fourteen years in a sort of jail over a small amount of money and a large amount of principle.

Barton, still recuperating from his wounds, and several other war veterans had heard stories of Vermont's beauty. It was a territory unsettled and basically there for the picking. Seeing an opportunity to provide security for their families and to continue their adventures in peacetime, a group of sixty veterans from Rhode Island and Massachusetts petitioned the independent republic of Vermont for a large piece of land that they wanted to clear and develop as a new town to be called Providence. When the petition was granted on October 20, 1781, the war had still not ended and the land had not been explored by the petitioners. Sometime within the next few months, the name of the land located in upper Vermont was changed to Barton, although at the time no one knew exactly why. Several years later, after Barton and the others had set up camp in the region, it was revealed that the old general had seen the petition and scratched out the name Providence and written in his own last name. By then, many of the original petitioners—including Ira Allen, brother of Ethan Allen, and John Paul Jones—had dropped out. Nothing was ever done about the name Barton, which exists to this day. Barton was known from then on as General Barton after his appointment as adjutant general of the Rhode Island Militia. Finally, the petition was chartered in 1789, and the first settlers began arriving in 1795, by which time small roads and mills had sprung up along the rivers.

Barton had developed fourteen acres to raise wheat and constructed a cabin in which to live. He did not send for his family, who lived comfortably in Rhode Island. He and Rhoda had raised nine children and all were content to stay in Rhode Island, although one of his sons made at least one journey to Barton, which even today is a nine-hour drive from Rhode Island.

In 1796, Barton built the town's first sawmill and later a large log cabin that housed a school and a church. Barton took no role in town meetings, although he was part of a three-man team that laid out the town. He did not vote on anything and seemed content to sell lots and timber, an activity that would cause him years of trouble.

In 1797, Barton sold a lot to Solomon Waldhams of Brookfield, Vermont—a lot already owned by someone else. Barton bought other parcels in tax sales and sold them as well. When Waldhams discovered

that he was not the sole owner of the lot, he sued and won a $225 judgment. Soon, others began filing against Barton, whose war record was apparently unknown to the settlers far from Rhode Island. Litigation went on for eleven years while Barton continued to do business. Finally, he sold a piece of land to Jonathan Allyn, who also discovered that he was not the only one who had a claim to it, and being the first town representative, he brought suit against Barton for $3,000, a large sum that caught the attention of everyone who had been taken. There were a judge, a congressman, a future governor and well-to-do merchants. They ganged up on Barton, who was ordered to pay. The court lowered the fine to $300, but still the old general refused to pay, claiming that he was a victim of circumstance. For him it was off to jail. William Barton was sixty-three years old.

There was no jail in Barton, Vermont, so Barton was sent to a log cabin used as the Caledonia County Prison in Danville, sixty miles south. Although not behind bars, he was forced to live in a yard surrounded by chains that stretched around trees for a mile out of town on the five roads leading to Danville. When word spread that a Revolutionary War hero was being held in Danville, people came to hear him relate the capture of

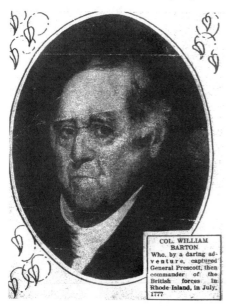

COL. WILLIAM BARTON.
Who, by a daring adventure, captured General Prescott, then commander of the British forces in Rhode Island, in July, 1777.

Prescott, which he was pleased to do. When the War of 1812 broke out, he petitioned Congress for back pay and compensation for the severe wounds he had suffered in the Battle of Rhode Island. The request was granted and the seventy-five pounds was sent to his wife Rhoda.

Following fourteen years in the Danville jail, Barton was seventy-seven years old and about to be sprung, much to his annoyance.

In 1824, President James Buchanan invited the Marquis de Lafayette to tour America one last time. The now elderly Marquis visited every one of the twenty-four states as the nation's guest, greeted by huge crowds at each stop. When

William Barton at the end of his life, still annoyed that Lafayette had bailed him out of prison in Vermont. *Courtesy of the Rhode Island Historical Society.*

he arrived in Providence, he looked up his old friend with whom he had dined fifty years before. He was surprised to learn from Rhoda that Barton had been in prison in Danville for fourteen years and had not been home to see her for thirty.

After making his way to Danville, the two old soldiers greeted each other warmly, but when Lafayette offered to pay Barton's fine, he was turned down by his old friend. Upon parting with Barton, Lafayette went to Burlington, Vermont, and found General Isaac Fletcher, to whom he wrote a draft for $300 with orders to have it used to pay the long-standing fine and set Barton free. Without a further word, Lafayette sailed on his ship *Brandywine* back to France.

Barton soon boarded a stagecoach and, while on the way home, sang patriotic songs with tears streaming down his seventy-seven-year-old face. Reunited with his family, Barton spent his final years receiving friends and visiting other family and relatives.

Catherine Williams, a local author, was friendly with Rhoda Barton, and after the general's death, she sat with her as she told the story of the last six years of his life. Much of what you are reading comes from her notes and small biography. Rhoda told Catherine of the time the general had been walking up a hill when he decided to rest on the doorstep of a large house. The mistress of the house sent one of her servants to investigate this old man fanning himself on her doorstep. The servant hurried back and said, "Why, la, ma'am, it is old General Barton, sat down to rest himself there, to be sure."

On October 22, 1831, Barton died of apoplexy. He was eighty-three years old. His death was felt throughout Rhode Island, and flags on ships in the bay and atop forts and buildings were lowered to half-staff. He was laid out in the house as people filed by his casket, upon which rested one of the swords given him by Congress. At three o'clock, a procession moved from the house to the North Burial Ground two miles away, where he was laid to rest. He was buried with full military honors.

Behind his stone is a small black marker that reads, "Jenny who spent a lifetime in the service of the Barton family."

# A LETTER FROM D-DAY

Millions of families, and especially young wives and mothers, spent the years during World War II wondering every day if their men would return safely. During the conflict, 416,800 military personnel were killed, most of them between 1941 and 1945.

Millions of letters were written home by GIs and provided great comfort to their worried families. Here is one from a navy officer who was aboard the first minesweeper that crossed the English Channel and led the way to the beaches at Normandy, France, on June 6, 1944. It was officially the Battle of Normandy, code name Operation Overlord. It was the largest seaborne invasion in history and began the second front of World War II. The minesweeper was followed by cruisers, destroyers, battleships and one thousand other craft carrying troops and supplies. The man who wrote this letter was John Laxton, the author's father.

He was a navy man doing his second tour, having been activated on October 22, 1940, trained in Boston and having served in the North Africa and Sicilian campaigns. He was now a thirty-seven-year-old warrant boatswain. He scanned the beaches of France looking for the first sign of enemy action.

"All was tense for most of the way," he wrote. "Everyone strained to see what was going to happen. They were a little scared but were prepared for the worst. And they prayed." Suddenly, "Hell broke loose and the very bloody affair followed. Out of the darkness the shrapnel from the German guns fell like hail. The enemy fire lighted the skies and gave us a good view of the action."

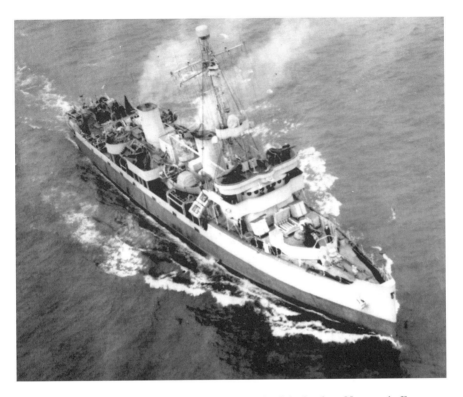

Photo of a minesweeper, the *Staff*, among the first to lead the battle at Normandy, France. *Author's collection.*

His job was to direct the plan of sweeping the beaches and remove mines as close to the French coast as possible. While carrying out these operations, members of the crew spotted a destroyer alongside their minesweeper that had been blown in two.

"We removed the wounded and took the survivors except the captain and a few others who were determined to stay on the ship and keep it afloat. There were some awful sights."

The following day, the Germans shelled it from the beach and sank it, killing the captain.

During the H-hour operations, he wrote, "800 transport planes towing gliders full of paratroopers flew over our heads with 1,500 bombers and 6,000 fighters." He described the skies as being black with planes and how thrilled he was probably never to see anything like that again.

Warrant Officer Laxton remembered in the days that followed, "we swept all over the place. Once we spotted some gun emplacements on the

beach and they started to fire on us. But we were lucky and no personnel were hit."

Years later, he still remembered being in his little minesweeper with Allied battleships firing at the entrenched Germans in the hills off the beaches and the Germans firing back, all the while bullets and bombs flying over his ship in both directions.

This letter was not received by my mother for a month, and she had no word whether he survived D-Day. On that fateful day, 1,465 men from the United States were killed and 5,138 were missing or captured. When word came that he had survived, my mother gave an ice cream party for the kids in the neighborhood, including her two-year-old son—me.

# A LONG OVERDUE MEMORIAL TO A FORGOTTEN SOLDIER

Y ou could hear the drum banging slowly and see the soldiers marching to its droning rhythm as they followed the caisson bearing the flag-draped casket that held the body of Private Michael McElroy, Second Regiment Rhode Island Infantry, Company D, to his final rest.

The scene was the North Burial Ground in Providence. The date was Saturday, May 31, 2008, and the Sons of Union Veterans of the Civil War were burying one of their own, who had died on July 11, 1888, at the Almshouse in Cranston, Rhode Island, where the poor and sick who could not take care of themselves or who had no family to help lived. Michael McElroy was forty-one years old and had stomach cancer. He was buried originally in the Old State Farm Cemetery in a pauper's grave, wearing only the hospital gown he had on when he died.

Michael McElroy was not to be forgotten, however.

He was born to Irish immigrant parents, John and Bridget, in Johnston, Rhode Island. His parents had both been born about 1820 and came to America in 1843 to escape the potato famine. John McElroy worked as a laborer and died in 1849, leaving four small children: Michael, Ann, Patrick and John.

On September 15, 1864, Michael eyed a $100 bounty being offered to recruits enlisted in the Second Regiment, Rhode Island Volunteers. He was sworn into the army by Justice G.A. Williamson on October 12. Being illiterate, he made an "X" before the judge and was officially mustered into Company D for a one-year term. His sparse records indicate a man only five

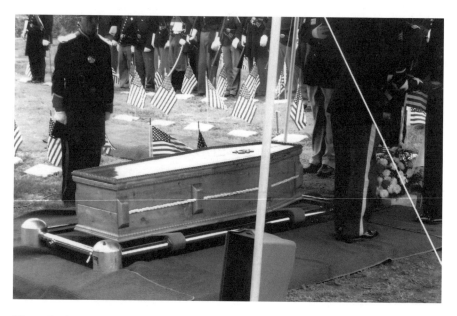

The casket bearing the body of a long lost Union solider arrives at the North Burial Ground in Providence, Rhode Island. *Author's collection.*

feet, three inches tall with hazel eyes, light hair and light complexion. Three weeks later, he was on his way to Virginia, one of the eighty-five officers and enlisted men in that company. Now part of the Sixth Corps, the Second Rhode Island was ordered to Petersburg and arrived at Parke Station, Virginia, by train on December 4. By December 9, they were officially in battle, acting as a diversion to help General Warren as they fought at Sussex Court House, thirty miles south of Petersburg. In two months, McElroy had marched hundreds of miles and taken part in several combat skirmishes.

McElroy and the Second played a major role when they charged into enemy territory on March 25, 1865, and took many prisoners after nearly being beaten back by the Confederates. The report stated that the Second had held its newly secured ground around Petersburg. On April 1, McElroy and his company were awakened early and ordered to prepare for a 4:00 a.m. attack on the Confederates. The Second was now acting on orders from Lieutenant Colonel Elisha Hunt Rhodes and was ordered to join in the attack on Fort Fisher at Petersburg, where they survived heavy rifle and cannon fire. Coming into Petersburg, they found that the enemy had evacuated that city, as well as nearby Richmond, and had destroyed any cannon or train that

could have been useful to the Union army. The Second Rhode Island caught up with Lee's troops at Sailor's Creek. It was hand-to-hand combat and heavy fire on both sides, with a large loss of life. The battle at Sailor's Creek sealed Lee's fate, and on April 9, he surrendered at Appomattox. The Sixth Corps paraded through Washington, D.C., and then were mustered out of the service and began the long trip home.

Michael McElroy's mother was working as a domestic in Pawtucket until at least 1870. There is no word as to what Michael did after the war, and at some point he went in to the almshouse in Cranston, where he died. McElroy was buried along with others who died in the poorhouse in a potter's field where Route 37 is near the Adult Correctional Institutions today. In the 1970s, the state simply paved over these graves when it expanded Route 37, obliterating several thousand graves of men, women and children. In June 2006, sixty-eight graves were unearthed by Mother Nature and the constant construction in that area and needed to be saved. One of those graves was that of Michael McElroy. Archaeologists were called and discovered a potter's field, once part of the state farm, part of three and a half acres set aside to bury one thousand residents of the farm between 1875 and 1918. They are

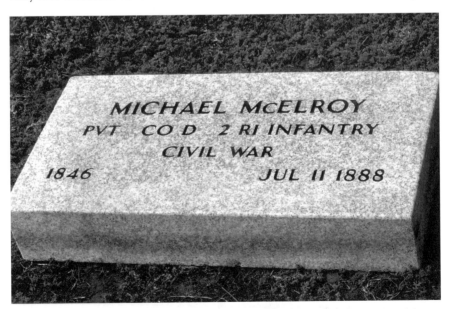

The final resting place of Private McElroy. *Author's collection.*

all under Route 37 today, but it was determined that the sixty-seven other graves would be exhumed and moved elsewhere due to the danger of them being exposed and washed onto open land in view of the public. Fifty-nine sets of remains were eventually identified after archaeologist Michael Hebert sent those names to historic groups, including the Sons of Union Veterans of the Civil War, who quickly identified McElroy by a plate that remained on the remnants of his burial vault. It was the first time that lost Civil War remains were found in Rhode Island. Twenty thousand Civil War veterans are buried in the state, but fewer than half have been identified.

Plans were made to afford Michael McElroy a proper burial with recognition he had never received when he died 120 years ago. The Sons of Union Veterans made a weekend out of the ceremony, with an encampment at North Burial Ground and a series of public activities to draw attention to the event.

McElroy's bones were brought to a holding area on the North Burial Ground and wrapped in a red wool blanket, similar to the one he was issued in 1864 when he enlisted. There was nothing found with him except four glass buttons from the gown in which he was buried. His teeth were in good shape and ground down from smoking a pipe. He was ready for a last ride from the holding vault to his spot on a slope near the front of the cemetery, where a cannon bearing the words Prescott Post #1, GAR, stands upright.

Two large gray horses slowly pulled the caisson, on top of which a beautiful authentic pine casket crafted by Robert Howe of North Scituate held McElroy's body. It came to a stop in front of the freshly dug grave and the casket was placed in a cement vault. The sons moved in a single file past the grave upon which each one placed a flower, followed by a military salute. Beyond the grave, the firing party of the Rhode Island National Guard advanced and fired three volleys. Several wreaths were laid at the foot of the grave and the following words were spoken: "Brothers: Our word is done and we bid our forefather farewell, until that bright morn when angel's reveille shall summon us to the last roll call on high. And may the blessing of God attend us all through life, enabling us to exemplify the great principles of our Order: Fraternity, Charity and Loyalty."

Today, the Civil War section of the North Burial Ground has a new stone, one that will remain clearer than all the others. It simply states: "Michael McElroy, Pvt Co D 2nd Rhode Island Infantry, Civil War 1846–July 11, 1888."

# ABOUT THE AUTHOR

A native Rhode Islander, Glenn Laxton is an Emmy Award–winning journalist who has worked in broadcasting in Rhode Island for more than forty years. He produced and narrated the WPRI television series *Not to Be Forgotten*, which chronicled the lives of unsung heroes of his home state. Those stories are available at www.nottobeforgotten.tv. In addition to writing for *Your Smithfield Magazine*, Glenn serves on the board of directors for the Rhode Island Heritage Hall of Fame and the Blackstone Valley Historical Society. He regularly gives talks and video presentations for historical societies and is the coauthor of *Rhode Island: A Genial History*.

Visit us at
www.historypress.net